The Museum Experience
East

The Museum Experience
East

Scott Douglass
Chattanooga State Technical Community College

Lawrence E. Butler
George Mason University

Sarah M. Iepson
Community College of Pennsylvania

Carol H. Krinsky
New York University

Barbara E. Mundy
Fordham University

THOMSON ™
WADSWORTH

Australia • Canada • Mexico • Singapore • Spain • United Kingdom • United States

Printer: Webcom

ISBN: 0495188689

Cover image: Janine Wiedel Photolibrary/Alamy

Thomson Wadsworth
10 Davis Drive
Belmont, CA 94002-3098
USA

For more information about our products,
contact us at:
Thomson Learning Academic Resource Center
1-800-423-0563

For permission to use material from this text or
product, submit a request online at
http://www.thomsonrights.com.
Any additional questions about permissions can be
submitted by email to **thomsonrights@thomson.com.**

CONTENTS

Chapter One
Visiting a Museum

As with so many opportunities of this nature, visiting a museum can be an exciting and rewarding experience—or it can prove disappointing and frustrating. Those who have enjoyed visiting a wide variety of museums eagerly anticipate the prospect of taking in yet another. But those who have not visited a museum might need a bit of persuasion to make that initial visit. This guide is intended to assist all who are considering a visit to a museum, regardless of your experiences.

Many readers will turn to this guide for specific assistance in writing a review of an exhibition or of a particular work of art. Because the guide offers a wide variety of insights intended to enrich anyone's visit to a museum, even those who have neither of these purposes in mind will likely benefit from reading these chapters.

Planning Your Visit

Your visit to the museum begins before you actually enter the building that houses the exhibits. In fact, it might begin a week or so in advance. A great way to prepare for your visit is to log on to the museum's website. A quick search with your favorite web browser will locate the URL for the museum's website. The information that you'll gather at the website will depend on the quality of the site's features and the time that you devote to investigating them.

The site's features will probably include the basic information that would help anyone planning a visit, particularly the museum's location and its hours of operation.

Many sites also include a calendar of events, usually on a monthly basis. For instance, like many museums, the Hunter Museum of American Art <www.huntermuseum.org/> in Chattanooga, Tennessee, offers "Freebie Friday" on the first Friday of each month, when no admission fee is charged. Such information might be especially helpful as you schedule your visit.

Other categories of information available on the website might include an overview of current exhibits as well as a virtual tour of the museum's collection. By becoming aware of exhibits currently featured at the museum you intend to visit, you'll know if you should schedule your visit so you can take advantage of the once-in-a-lifetime opportunity to view the Renoir exhibit that will be in town for a limited time. Similarly, by investing an hour or so to take the virtual tour, you'll gain valuable insights to help you prepare for your "real-time" visit. You could identify specific portions that you find especially interesting and then plan to devote sufficient time to viewing them. In addition, if your visit to the museum will culminate in your writing a review, information on the website might help you identify the piece or pieces on which you'd like to focus your attention.

Even if you capitalize on the information provided by the museum's website, call the museum's office a day or two in advance of your visit. As you've probably realized from other situations, material posted to the website might be out of date when you view it. A well-timed phone call allows you to confirm the museum's hours of operation and ticket prices, plus you can inquire about extended hours or discount admission for which you might qualify.

A few hours of preparation, then, can be extremely beneficial for your museum visit. Many visitors find it especially helpful to make a "Top 10" list of the works of art that they want to be certain to view. When you arrive, ask the staff member at the information desk for specific locations. The museum's staff wants to make your visit an enjoyable and memorable experience. Keep this in mind throughout your visit as well.

Museum Etiquette

A museum's two chief responsibilities compel it to exist in a perpetual dilemma. The museum's collection must be protected, of course, but visitors must be permitted to view and enjoy it. If the collection is merely locked in a vault, it will be preserved, but it won't be enjoyed. Then we must wonder for what purpose is the collection being preserved?

Even before you enter the exhibit areas, you'll encounter several of the museum's security measures. Most museums require that backpacks, briefcases, packages, and any other handheld objects be subject to inspection. If you refuse to submit to an inspection, the security officer will probably deny you entry. Many of these items—particularly a backpack and even an umbrella—are not allowed inside, so you'll be wise to leave them at home or in your car. Some museums offer limited locker rentals, but don't count on it.

You'll often encounter other security restrictions as well. While many museums offer areas for dining—from light snacks to extensive meals—food and beverage will not be permitted into the exhibition areas. Cameras of any kind are usually prohibited; flash photography is rarely permitted. If you're accompanied by a younger sibling or friend, be prepared to confirm that you are an adult, willing to be responsible for your companion's behavior. If someone in your group is quite young, be prepared to find that strollers are not permitted in the museum or, more likely, in some areas. (A telephone call in advance will help you avoid an awkward situation as you enter the facilities.) And if your group is fairly large, each member might be asked to wear a visitor badge.

Because a museum is a home for rare and priceless works of art, guidelines must be established so that the museum can fulfill its two chief responsibilities—protecting its works of art and permitting visitors to view them. It seems fair, then, that you as a visitor have two chief responsibilities: Be cautious as you view the exhibits and be considerate of other visitors (those visiting on the day of your visit and those who will do so in the years to come).

PART ONE

Virtually every museum depends on its visitors' adherence to a general set of guidelines, whether or not the guidelines are posted on signs or prescribed in a brochure. Although some visitors might consider them a nuisance, the guidelines are intended to protect the collection, not to inconvenience the visitor. If the choice has to be made, though, the museum will prefer the safety of its artifacts to the comfort of its visitors. Here are some general guidelines that museums commonly assume their visitors to observe.

- **Avoid touching the works of art.**
 Stay at least an arm's length away from the displays. Even pointing at objects might raise unnecessary concerns among the museum's security personnel. You might benefit from folding your arms or putting your hands in your pockets.

- **Avoid walking behind the ropes.**
 The ropes are placed to establish an area of safety for the work of art. Your intrusion into that space might set off an alarm and you might share an uncomfortable moment with the museum's security personnel.

- **Avoid using a display case as support for writing or sketching.**
 Too much pressure with your pencil might scratch the glass. Even more pressure might break the glass. Instead, use one of the museum's brochures. Better yet, come equipped with a notebook or a clipboard.

- **Avoid leaning on a display to steady your camera.**
 As you concentrate on framing the shot and seek to steady your body for a perfect photograph, you might not realize that your shoulder has found support from a thousand-pound ancient Egyptian stone artifact. Again, avoid that uncomfortable moment with the security personnel.

Accompanying these policies to protect the works of art are guidelines designed to allow each visitor to have an enjoyable and enriching museum visit. Most of the guidelines are based on good manners. When you recall that many museum visitors read display labels, listen to an audiotape, and share ideas about the works of art, you'll understand how many of these guidelines evolved to help everyone concentrate and enjoy.

- **Speak in quiet tones.**

 Think of the museum's atmosphere as similar to that of a library. Feel free to comment about the art and share your opinions with companions. Be thoughtful of other visitors, though. Avoid speaking at a volume that inadvertently shares your opinions with those who are not in your party and who probably have no interest.

- **Walk calmly and respectfully.**

 Maintaining a moderate—even a slow—pace allows you time to examine the works of art. You also avoid distracting others who have come to view stationary art rather than inconsiderate visitors zipping by. Again, consider the library's atmosphere.

- **Wait for others to finish at an exhibit.**

 Many visitors pause near a work of art to reflect on its meaning and the artist's intentions. Be watchful for such a situation and respect their time and space. After they've moved on, you may then approach the display.

Capitalizing on Your Visit

During your visit, you may move freely throughout the galleries. You might be surprised, though, by how tiring a museum visit can be. Most people find that a visit of a few hours is sufficient. Depending on the museum's size, your advance

preparation for the visit will help you see more and tire less. An especially useful way to prepare in advance is to wear comfortable shoes. Another method of delaying the fatigue that almost certainly intrudes at some point during the visit is to take breaks throughout your visit. Many museums have your tired feet in mind when they place comfortable seating areas in the galleries. If you're fortunate, you might find a seat near a work of art that you consider especially appealing. With that extra amount of time to enjoy the work, your rest will be all the more refreshing. Another seat might seem far from the artwork until you realize that the building's architecture is itself a work of art worth your attention. And if these options aren't successful in reviving you, visit the museum's cafeteria for a snack.

When the museum hosts a special exhibition, however, the traffic pattern is controlled in anticipation of the large crowds that will attend. In fact, the museum will restrict the number of visitors at specific times, often selling a limited number of tickets. Being aware of these circumstances will help you avoid missing a wonderful opportunity.

One approach to visiting a museum is to walk through all of the galleries, pausing only at those works of art that appeal to you. If you realize that a single visit won't permit you to walk through all of the galleries, you can choose an alternative approach that involves concentrating on a few of the galleries that you find most appealing. Your preparation for the visit—through the website and the phone call—will pay dividends here.

Whatever approach you choose, one of the best ways to make your visit more enjoyable is by taking advantage of the aids that the museum offers.

Figure 1: Typical Display in a Museum

Featuring the work of art and the display card (which has been enlarged)

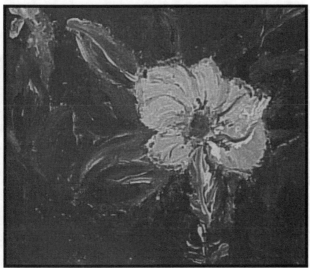

Brian Douglass
United States
1985 –
The First Burst of Spring
1994
acrylic on canvas
8 inches X 10 inches
acquired through anonymous gift

Brian Douglass

United States

1985 –

The First Burst of Spring

1994

acrylic on canvas

8 inches X 10 inches

acquired through anonymous gift

PART ONE

Written Materials

To help you enjoy your visit, many museums offer a variety of written materials. Among the most useful is a museum floor plan, which serves as a map to help you locate exhibits. An entire floor, for example, might be devoted to a historical period (Pre-Columbian), a geographical region (New England), or a style of art (Impressionism). As you tour the museum, look near each work of art for a small plaque that provides essential information related to the work (see Figure 1).

Depending on the occasion, some museums provide other printed materials as well. An exhibit of a single artist's work, for example, might prompt the museum to provide a single-page pamphlet that describes the artist's technique and offers biographical information about the artist. An exhibit of the work of multiple artists might call for a more complex brochure, with perhaps a page devoted to each artist, her biography and technique. And then for an exhibition of the work of a celebrated artist (Mary Cassatt, for example), the museum will offer an elaborate catalogue for purchase. These are truly fine souvenirs, providing biographical information, informative commentary, and reproductions of the exhibit's works.

Audiotapes

An exhibition of a celebrated artist's work might also be accompanied by an audiotape that provides informative commentary about the works and the artist's techniques. For a nominal fee, you may rent the tapes along with a player and headphones, and then return all of these items to a convenient location at the conclusion of your visit.

Docents

Many museum staffs include docents, who serve as tour guides and are outstanding resources eager and able to answer your questions. To become a docent, each person must undergo thorough training to learn about the museum's

collection and its special exhibits. Because of their excellent service—usually in a volunteer capacity—docents are respected and admired by everyone closely associated with the museum. Inquire at the information desk for details on how you might join a docent's tour. And even if you don't join a tour, you might listen in on the docent's comments when you encounter her tour as you visit independently.

Enjoy Your Visit

You'll know that your visit has been a success if you leave the museum with the satisfaction that you've seen several memorable works of art. You'll be even more fortunate if you consider some of these works so exceptional that they remain in your mind for weeks to come. With an appropriate measure of preparation, your museum visit can be a stimulating and enriching experience. Perhaps the most useful bit of advice is to ask questions. Learn, enjoy, and return with a friend.

PART ONE

Activities

The following activities are intended to help you become familiar with what you'll likely encounter on display when you visit a museum.

Activity 1.1: A Virtual Visit to a Museum

Take a virtual tour of the Montreal Museum of Art's collections by visiting its website <www.mbam.qc.ca/lundi/a-cyber-lundi.html>. Select one of the galleries, where you'll find several works of art available for a closer look. When you select one of the paintings within the gallery, you'll find accompanying information:

> Artist's name
> > nationality
> > year of birth and year of death
> Artwork's title
> > year of completion
> > technique (e.g., oil on canvas)
> > dimensions
> Museum's method of acquisition (often a bequest)

Activity 1.2: A Virtual Visit to a Museum

In some instances, museums provide further insights about works of art. The Welsh National Gallery's virtual display for Pierre-Auguste Renoir's *La Parisienne* [*The Parisian Girl*], for example, supplements the customary information with an explanation of the artist's intentions as well as biographical information about the woman who sat for the artist. To learn more about the painting, the artist, his subject, and the connection to the Impressionist movement, visit the web page for Renoir's piece <www.museumwales.ac.uk/en/art/online/?action=show_item&item=1534>.

Chapter Two
Selecting a Piece to Review

During your museum visit, allow enough time to look at each work, some more closely than others. For those of particular interest to you, gain further insights by reading the accompanying text on the display card or in the brochure. Be certain to note the location so you can return later for further scrutiny. After you've completed this initial "walk through" of the museum, return to several of the works that made significant impressions on you.

Perhaps you have a special fondness for a particular model of automobile. Have you paused to consider why it interests you? Is its color a key factor? Or is it the body style in general—regardless of color—that appeals to you? In a similar way, studying a particular piece of art in more depth can help you become more aware of your response to the piece. In fact, a closer examination of the work can be an extremely rewarding experience. It can lead to a more solid understanding of a work or an artist, sharpen your analytical eye, and increase your appreciation for art in general.

Do you occasionally see one of your favorite automobiles parked at Wal-Mart and catch yourself imagining that you're its owner? Now and in the future, you might also encounter an especially intriguing piece of art that compels you to pause, reflect, and even purchase it so you can place it in your home and admire it for many years to come.

Chapter Three provides information that will help you increase your enjoyment in a work—even if you're not writing a review. With an awareness of the

elements and principles discussed in Chapter Three, you'll have more thorough appreciation of what an artist is trying to convey.

Recalling the Assignment

Your Art Appreciation or Art History instructor may ask you to write a review of a museum exhibit or of a single work of art that you find especially interesting during your museum visit. If such is the case, be sure to recall the assignment specifics on your trip.

As you prepare to write the review, of course, you'll need to select a piece (or pieces) that lend themselves to your complying with the assignment's specific details. To accomplish this, you'll need to have a written copy of the assignment with you as you move through the museum. Don't trust to your memory. A minor oversight undetected until you've left the museum might necessitate a return visit. While that might not seem a severe penalty, the time devoted to correcting the oversight might delay your completing the assignment and risk late submission. Go to the museum fully prepared.

The information you'll need also depends on the assignment's specific requirements. Almost certainly, though, you'll need the title, the artist, the date of completion, the work's dimensions, and the medium. In addition, you should record any other information that you find on the display card (see Figure 2.1) and have the slightest suspicion that it might prove helpful as you write the review.

Figure 2.1: Typical Display in a Museum

Featuring the work of art and the display card (which has been enlarged).

Brian Douglass
United States
1985 –
The First Burst of Spring
1994
acrylic on canvas
8 inches X 10 inches
acquired through anonymous gift

Brian Douglass

United States

1985 –

The First Burst of Spring

1994

acrylic on canvas

8 inches X 10 inches

acquired through anonymous gift

PART ONE

Recalling the Museum's Website

From your time on the museum's website before your visit in the museum you might recall the extent of the website's contents for selected works. Unless you can return to the website during your museum visit, however, you should avoid trusting your memory about specific details found on the website. If you're fairly confident that the work of art you select is featured on the website, then you can return to the website following your museum visit to confirm what you record in your notes. If you have any doubt, though, record detailed notes and assume that the website will provide little assistance.

You might also obtain a copy of any printed material—pamphlet, brochure, or catalogue—because it will contain accurate information. Unfortunately, though, because a museum's holdings are often so extensive, the printed materials rarely feature every work of art. If the piece that you select is not among those examined in the printed materials that you gather, then you've lost the advantage these items can provide.

Above all, realize that there's no substitute for the detailed notes you record as you view the work of art and devote serious thought to it. If you have the necessary information recorded in your notes, then you'll be far more confident that you're prepared to write the review. Later, you can consult the website or the printed materials. And, if necessary, you can return to the museum.

Activities

Anticipating and addressing the unlimited possibilities available to the assignment for you review far exceeds the scope of this chapter. The following activities, however, are intended to help you prepare for a museum visit that will culminate in a written review. These activities provide options similar to those that are commonly involved in review assignments. Although the opportunity to visit a museum with some of the great masterpieces on display is not an everyday occurrence for most of us, you can devote time to these activities and then apply the experiences you gain to the works of art that you view during your museum visit.

Activity 2.1: Portrait of a Historical Figure

Visit the website for the National Gallery of Art in Washington, D.C., to view Stuart Gilbert's portrait of John Jay, the first Chief Justice of the United States <www.nga.gov/collection/gallery/gg60a/gg60a-73857.0.html>. In the information that accompanies the portrait, note the insight about how the Chief Justice's busy schedule interfered with his sitting for his portrait and how Gilbert overcame this obstacle. Nevertheless, Chief Justice Jay must have been pleased with Gilbert's painting—so much so that he wrote a letter of introduction that advanced Gilbert's career. For further insights about this episode, see another of Gilbert's portraits available at the National Gallery's website <www.nga.gov/collection/gallery/gg60a/gg60a-1124.0.html>.

Activity 2.2: Portrait of a Not-So-Famous Figure

A portrait's appeal doesn't necessarily depend on the subject's status or fame. Nor does it require a formal setting. Visit the website for the National Portrait Gallery in Washington, D.C., to view Mary Cassatt's *Child in a Straw Hat* <www.nga.gov/collection/gallery/ggcassattptg/ggcassattptg-61101.0.html>. Why has Cassatt chosen to depict the girl in an informal pose? Speculate about the situation leading up to this portrait. Does the child's expression provide insights about her opinion of having her portrait painted?

Activity 2.3: Capturing a Historical Event

In *Christopher Columbus and His Son at La Rábida*, Eugène Delacroix captures Columbus "at the final moment of frustration before his ultimate triumph"— when he had virtually given up all hope for making his first voyage to what proved to be the "New World." View this painting <www.nga.gov/collection/gallery/gg93/gg93-46319.0.html> at the website for the National Gallery in Washington, D.C. Note how the information accompanying the painting contributes to our perception of the artist's intentions, particularly in light of the Romantic Movement. Discuss how the historical background increases your opinion of the work of art.

Activity 2.4: Symbolism in Jacques-Louis David's *The Emperor Napoleon in His Study at the Tuileries*

Visit the website for the National Gallery of Art in Washington, D.C., to view Jacques-Louis David's *The Emperor Napoleon in His Study at the Tuileries* <www.nga.gov/collection/gallery/gg56/gg56-45831.0.html>. Be sure to devote particular attention to the collection of items—book, maps, and papers—placed within the emperor's reach. Then comment on David's success in reflecting on "three aspects of [Napoleon's] public image: soldier, emperor, and administrator."

Activity 2.5: Identifying Characters

An encounter with a work of art that includes a large number of famous characters is greeted as a challenge by many museum visitors, who devote hours to identifying the figures present. Raphael anticipated this penchant by providing *School of Athens*, a fresco in the Vatican's Stanza della Segnatura. At the New Banner Institute website <www.newbanner.com/AboutPic/athena/raphael/nbi_ath4.html>, an enlightening "answer key" is available. Note especially the identity of the figure depicted front and center, at the bottom of the painting. Then undertake a search for Raphael, who included his own likeness. (Hint: He's far to the right side.) When you encounter such a work of art, accept the challenge and utilize the tools (pamphlet, brochure, or catalogue) provided by the museum. You'll realize that such enlightenment enriches the pleasure you'll find in the work.

Activity 2.6: Landscape

Can you feel the cold captured in John Henry Twachtman's *Winter Harmony* <www.nga.gov/collection/gallery/gg70/gg70-49975.0.html>? Before photography was commonplace, artists were the primary hope for preserving landscapes. Painting a pond surrounded by trees on a snow-covered bank requires a significant measure of talent. But imagine the extraordinary genius necessary to enshroud the entire scene in a fog. During your museum visit, look for landscapes that make you feel truly a part of the scene.

Activity 2.7: Use of Light and Darkness

Sharp contrasts involving light and darkness assist the artist in focusing the viewer's attention. One of the masters of this technique is Michelangelo Merisi, better known as Caravaggio and often called the "other" Michelangelo. In *The Calling of St. Matthew* <gallery.euroweb.hu/html/c/caravagg/04/23conta.html>, Caravaggio directs the viewer's attention to Matthew rather than to Jesus, who gestures to summon the startled tax collector. During your museum visit, look for works of art that use sharp contrasts in light and darkness to convey some measure of the artist's intentions.

Activity 2.8: Focal Point

Artists draw from a wide assortment of devices to entice their audiences to view their works. Diego Velázquez combined several techniques in *Las Meniñas* <gallery.euroweb.hu/html/v/velazque/1651-60/08menina.html>, intending those in his audience to consider themselves "present" in the painting. Through contrasting light and darkness, the viewer's attention is obviously directed to the Infanta Margarita, who is surrounded by her attendants. A glance beyond the princess's head and slightly to the left detects much more, though. A mirror's reflection reveals the Spanish King and Queen, who are also present in the scene but are standing beside the viewer. During your museum visit, notice other techniques that artists utilize to direct the audience's attention to the primary focal point.

Activity 2.9: Depth of Field

A first encounter with the works of Andrea Mantegna often overwhelms even the most casual art observer. When you view *The Lamentation over the Dead Christ* <gallery.euroweb.hu/html/m/mantegna/2/dead_chr.html>, you'll have an idea of this artist's skills. When you realize that this painting is on a flat canvas surface, you'll appreciate Mantegna's remarkable mastery of conveying depth of field. With the left mouse button, click on the image to enlarge it. Then notice that the feet seem literally to extend beyond the edge of the table and off the canvas. Note also the torn flesh surrounding the nail wounds. During your museum visit, look for other works of art that seem to include depth—the third dimension—with height and width.

Activity 2.10: When You Don't Know What to Say

Certainly, it's acceptable to dislike some of the works of art that you encounter. But between the categories of "like" and "dislike" stands another sort that perplexes us. Occasionally, we encounter works of art so puzzling that we have difficulty expressing our responses. Many of Hieronymus Bosch's works often create this situation. For a better understanding of the confusion that often arises, visit the *Bosch Universe* website <www.boschuniverse.org/> and follow links to two of his more intriguing works, *The Garden of Earthly Delights* and *The Last Judgment*. You'll likely encounter others during your museum visit. Don't avoid them, however. Give them a genuine chance to "speak" to you.

Chapter Three
Responding to Art

Recording the information mentioned in the previous chapter will prove helpful in providing the background details about the work of art that you've selected as the basis for your review. But rarely does a review assignment deal solely with the background details. To achieve the far more important aspects of the assignment, you must incorporate your response to the artwork.

When you determined which piece of art you'd use for the review, you likely did so because you experienced a strong reaction to it. Searching beyond the work's surface appearance is extremely important as you analyze the work and express your reaction to it. Avoid relying merely on a basic response that the work is "pretty." Your strong reaction might include a variety of sentiments, each reflecting an emotional reaction. For example, you might consider the work of art disturbing, upsetting, emotionally draining, or politically charged.

Recording the details of that reaction is extremely important to your writing the review. Don't depend on your memory. Don't delay until after you've left the museum to record your thoughts. Instead, write down as much as you can recall about your initial response to the piece. Record notes directly in the museum's brochure (if one is available) and connect your comments to specific aspects in the photographic reproduction of the piece.

If the brochure is not available, do your best to sketch the artwork. The sketch is intended to supplement your notes, so avoid becoming concerned with the quality of your sketch. Instead, concentrate on recording your thoughts and

responses to the piece. Because you need not share your sketch with anyone, you shouldn't be concerned about its quality. If you record details sufficient for you to recall your intentions, then the sketch is successful.

Recording your initial reaction and then examining the work more closely to make the sketch will help you write the review. Perhaps you've depended upon a similar method of memorizing a list of vocabulary words. Re-writing the list and then reading the words in your own handwriting can prove quite beneficial when you must later write the words on a quiz. Similarly, your comments and your sketch will work together to help you react more completely and generate a significant response on which you can base your review.

Suggestions for Sketching

If you don't consider yourself artistically talented, then you might begin by creating a thumbnail sketch that captures the artwork's basic design. The thumbnail sketch is intended to record an overall view rather than a detailed analysis. If this work of art truly appealed to you—it seemed to reach out and grab your attention when you first entered the exhibit area—then you were probably responding to the features that your thumbnail should capture.

For the inexperienced artist, this less complex method of capturing the whole instead of the details will result in a more useful sketch. You've probably applied this method to other works—of music and of literature. Consider Beethoven's Fifth Symphony. Few of us could hum the entire work, but all of us can hum "tah-tah-tah-tum"—the "part" that Beethoven clearly intended to relate to the "whole." Similarly, reciting all of Edgar Allan Poe's "The Raven" isn't a talent boasted by many. But most of us recognize the refrain "Nevermore."

The task might be more manageable if you divide your "canvas" into quadrants. Imagine the piece of paper on which you're recording your sketch to be the work of art that you've selected. Begin by drawing two crossing lines to establish equal quadrants. Next, *imagine* identical lines on the work of art. Now, instead of sketching the entire piece, you've divided the task into four separate sketches that

will merge to reproduce the original. These divisions might also help you realize the principles of balance, motion, and emphasis that the artist incorporates in her work.

Providing color and value in your sketch can be fairly simple to accomplish. If the museum permits, use colored pencils. Otherwise, label areas of your sketch to capture its elements and your responses to them. Recall that your primary goal is not to reproduce the work of art. Instead, your purpose is to record your reaction to various aspects that you detected in the artwork.

Capturing texture in your sketch might be far more challenging. Recording notes that relate to the piece's texture, therefore, become extremely important if it is an element that you intend to address in your review. For instance, the website's reproduction of the artwork will likely lose some of the texture's qualities. As a result, your notes become all the more important.

Using a Checklist

After you have your sketch, make sure that you have all of the information you'll need before you leave the museum. The checklist on the following page details the aspects of a work of art that you should examine. Each is a little clue that can help you fully understand a piece, come to a conclusion about its meaning and effectiveness, and then write a good review or paper if your class requires one. You may want to take notes on these details during your visit.

Checklist: Notes to Take on Your Selected Artwork

The Basics

☐ Write down all of the information from the work's display card:

 ☐ artist's name ☐ work's title

 ☐ artist's nationality ☐ date the work was completed

 ☐ dates of artist's birth and death ☐ work's dimensions

 ☐ the museum's method of acquisition ☐ medium and technique

 ☐ any additional information you feel may be important

☐ What is your initial reaction to the piece?

Describe how the artist uses the elements of art within this piece.

☐ Line ☐ Light and Value

☐ Space ☐ Shape, Volume, and Mass

☐ Color ☐ Time and Motion

☐ Texture

Describe how the artist uses the principles of design within this piece.

☐ Emphasis / Focal Point ☐ Unity and Variety

☐ Balance ☐ Rhythm

☐ Scale and Proportion

Context, Content, and Meaning

☐ From your prior research and what you've learned from your museum visit, what is the cultural and historical context of your selected piece? Can you categorize it with a stylistic period?

☐ What is the content? What is going on? Try to identify people, the setting or location, and familiar objects.

☐ Can you pinpoint any themes? Is there any symbolism at work?

☐ Record your thoughts and emotions toward the piece. What do you think the artist wants you to feel when viewing his or her work?

☐ Putting all of these clues together, what is the meaning of the artwork? What do you think the artist is trying to say or do? And do you think that he or she is successful?

Figure 3.1: Steps in Sketching

The following steps might help you record a recognizable sketch of the original work of art.

1) Draw two crossing lines on your "canvas" to establish quadrants.

2) *Imagine* identical lines on the work of art.

3) Make separate sketches of key features in the four areas.

4) Include notes to indicate colors.

PART ONE

Activities

The following activities are designed to encourage you to respond in multiple ways to a single work of art and to prepare you to record your thoughts as you prepare to write a review.

Activity 3.1
From the Appendix, select and connect to the website for a museum that you'd like to visit. Locate a work of art that appeals to you. Next, use a black-lead pencil to make a thumbnail sketch that captures the piece's basic design. Then record a minimum of five notes that address the work's color, value, and texture.

Activity 3.2
Using the same work of art as you selected for Activity 3.1, describe it using the following terms, as they are associated with art.

1. line
2. shape
3. value
4. color
5. space
6. texture
7. balance

Activity 3.3
Now describe the same work, using colloquial terms (e.g., "The bowl's octagonal shape is appealing," "This shade of green reminds me of the leaves on the weeping willow tree in my grandmother's backyard," or "The texture of the pitcher's handle seems unusual").

Activity 3.4

Again, using the same work of art as you selected for Activity 3.1, provide a psychological response based on your feelings and thoughts (e.g., "When I first saw the painting's row of buildings, I felt uncomfortable because I was reminded of my dentist's office").

Activity 3.5

Still with the same work of art as you selected for Activity 3.1, provide a judgment and explain your reasons for reaching this conclusion.

Chapter Four
Writing a Review

With the museum visit behind you, with appropriate notes recorded, and with an admirable sketch (if you do say so yourself) in hand, you've made significant progress toward being prepared to write the review. But a few steps remain before you're truly ready to write.

Purpose and Audience

Most students undertake the task of writing a review of a work of art because their instructor has made an assignment with specific requirements. Be certain that you have thorough understanding of your instructor's expectations. Your notes and sketch can't help if you don't have your instructor's specifications in mind as you embark on writing the review.

In many instances, though, other factors play a role in the point of view you adopt as you write the review. For example, you might assume that your audience is considering a visit to the museum. If this were the case, your review might be intended to convince your reader that a visit is certainly worthwhile, if merely to view the artwork on which your review focuses its attention. A second situation could involve your providing a review of a piece of art as representative of an exhibit that your audience is unable to attend. Your review, then, will provide insights that your audience will not have an opportunity to gain otherwise. Yet another possibility is that

your review might evaluate an entire exhibit that includes multiple pieces by a single or by multiple artists.

Your review will certainly depend on your expressing your opinion. But you should resist the temptation to think that your audience will accept your comments simply because they appear in print. For an art critic's opinion to find acceptance, the audience must be convinced that the comments are based on a reasonable and unbiased analysis supported by solid evidence that reflects a clear knowledge of terms and concepts associated with art.

Organization

The next step in writing the review is to arrange your notes so you can draw from them with ease as you move to the next steps in the process. Your notes should include—at the minimum—the following categories.

name of work	subject matter	unique qualities
name of artist(s)	artistic style used	social influences
media utilized	formal elements	historical allusions
theme		

If any of these items is not mentioned in your notes, you might return to the museum, rely on the museum's website, or consult an alternative website from among those mentioned in the Appendix. While you might not use all of this information, you won't suffer from having too much rather than too little.

Establishing a Thesis

With your notes arranged and fresh on your mind, you can develop a thesis that responds to the assignment's specific requirements. Don't expect the thesis to be a masterpiece at this point in the writing process, though. To get the writing process underway, however, you must have some sort of thesis as a guide. A

"working" thesis—one that gets your writing going, but isn't binding—will suffice. As you continue beyond the thesis and express your thoughts in writing, you might realize that a modified approach is preferable. You might even choose a completely different approach altogether.

The Review's Introduction

As with any piece of writing, your review's introduction plays an extremely important role in your review's overall success. Beyond the title (which we'll address soon), the introduction is the your first opportunity to capture the reader's attention and entice him to continue reading. If you lose your reader at this point, then the rest of your review—regardless of its beauty—is lost.

Determining the proper approach for your review can pose quite an obstacle. Most writers find success is writing *something* just to get the project underway. Perhaps your instructor has stipulated that your review begin with a summary of the basic information that identifies the work on which your review focuses. Consider the points that you could include: identify the museum as well as the work's title, subject, and artist; and then mention the technical details (e.g., medium and size). Even if these details are not required, presenting them in the opening paragraph will get the project rolling. You can return later to revise and modify, as you deem appropriate.

The introductory paragraph is the appropriate location for your "working" thesis. Remember that it is not binding at this point in the writing process. Placing the thesis as the introductory paragraph's concluding sentence will allow you to refer to it with ease as you write the rest of your review. During the final revision, you can place the thesis where you think it works best.

The Review's Body

The body paragraphs expand on the thesis. If your thesis lists the points of your argument, be certain that you address all of them and follow the order prescribed by the thesis. It's certainly acceptable for your thesis not to list the

elements explicitly; nonetheless, you must devise a logical and coherent order in which you present the elements. Also, remember to include each required element if you're writing the review to complete an assignment for class. A review that is otherwise brilliant might not receive a passing score if it does not fulfill the assignment's minimum requirements.

Within each body paragraph, recall the guidelines commonly associated with body paragraphs for virtually any essay. Provide a clearly stated topic sentence that presents the paragraph's subject. While the topic sentence can appear anywhere within the paragraph, it is often most successful when positioned as the paragraph's first sentence. In addition, compose each body paragraph with these characteristics: logical unity, adequate development, plausible organization, and sensible coherence.

The Review's Conclusion

Because the conclusion plays a major role in your review, be certain to capitalize on this final opportunity to persuade your reader to accept your views. Avoid merely restating the points you've already made in the review. If your final words lack the spark that your previous paragraphs have led your reader to expect, then the bored reader—even if he has accepted your opinions up to this point—might turn against you. Your reader expects more. And the energy that you've devoted to your review justifies better.

Instead, you might provide an enlightening conclusion by drawing an inference derived from the information that you've presented in the preceding paragraphs. This is not to suggest that you introduce a new concept, idea, or topic. Quite to the contrary, the conclusion is not the appropriate location for introducing new material. Clearly, a successful conclusion brings the review to a close. But it may do so while enriching it.

PART ONE

The Review's Title

With this first draft of the review completed, you're in a position to create a title. You might have devoted little attention to devising the title for a composition written in a college literature class. Because your instructor might be your only reader, you might view the essay's title as merely a necessary detail.

The title for your review, however, plays a major role in the review's success. Compare your review's title to the color of a car that you might purchase. If your first glance at a car reveals a color that doesn't appeal to you, then you'll probably give it little further attention, even though it might meet all of your other needs (price is right, low mileage, spotless interior, and great tires).

Certainly you want to attract the reader's attention, but the title plays an even more valuable role in the review's success if it reflects the spirit of the written work. You might draw from the artwork's title, from the artist's name, or from the style of art. But don't simply entitle your review "Manet's Impressionistic Style as Seen in *Le Déjeuner sur l'Herbe [Luncheon on the Grass]*." Boring? Yes. Intriguing? No. Longwinded? Yes. Informative? No. Instead, consider the brevity and appeal of "Join Manet for Lunch." The title's multi-faceted role urges you to devote significant attention.

The Finishing Touches

After you've written the entire review and topped it off with an especially clever title, don't overlook the final step in any worthwhile writing process. Because this step frequently pays great dividends, its value to your review's success is no less than the others'.

Proofread your review closely, looking for blatant errors, of course, but also for subtle problems that you might have overlooked earlier. Such problems involve much more than the computer software's spell-checker. The most frequently occurring problems that inexperienced writers encounter at this point in the writing process result from their assuming that the composition contains their intentions,

even though this is not necessarily the case. (In other words, the writer knows what the review is supposed to say, but it just doesn't say it.) To overcome this obstacle, you must use your most discerning eye as you scrutinize your review.

Checklist: Proofreading, Revising, and Editing

As you proofread and then revise and edit your review, ask yourself these questions:

Introduction

☐ Does the introduction present specific details?

☐ Have required aspects been adequately addressed?

(if you're writing the review in response to an instructor's assignment)

Thesis

☐ Is the thesis statement clearly stated?

☐ Are you satisfied with its location?

☐ Do you tell your reader what you intend for your review to prove?

Body

☐ Is each topic sentence easily discernible?

☐ Are you satisfied with its location?

☐ Does each body paragraph display logical unity?

☐ Is each topic adequately developed?

☐ Is each topic supported with evidence and facts?

☐ Is the organization of each body paragraph plausible?

☐ Is each body paragraph sensibly coherent?

Conclusion

☐ Does the conclusion bring the review to a close?

☐ Does it avoid introducing a new concept, idea, or topic?

☐ Does it draw an inference intended to enrich the review's discussion?

A Final Revision Step

After you've looked closely at the review's overall structure, put it aside and allow it to "rest." If a day or two are available, use them to withdraw from your review. Then, when you return to give it a final inspection, you'll be far more likely to detect problems that you'd overlooked in the previous proofreading. Use these questions as guides:

Throughout

☐ Have you provided well-constructed sentences?
☐ Have you eliminated all fragments and run-on sentences?
☐ Have you included correct punctuation?
☐ Have you carefully selected words appropriate to your topic?
☐ Are sources correctly cited?
☐ Does the review address all requirements included in the assignment?

PART ONE

A Sample Review

In the following selection, student-writer David Padilla reviews Willem de Kooning's *Untitled* (1969) in response to an assignment that required selecting a work of art, identifying its style, and then justifying its classification. To enhance your understanding of Padilla's comments, visit the website for the Hunter Museum of American Art <www.huntermuseum.org/l>, where you can see a reproduction of de Kooning's painting. On the museum's home page, follow the "collection" link, and then scroll down until you locate *Untitled*.

As you read the review, note these aspects that contribute to the review's success. In the introduction, Padilla provides a brief overview of Abstract Expressionism before informing the reader of the specific work on which his review will focus. The second paragraph examines one characteristic that confirms the painting as an example of Abstract Expressionism: its depiction of "abstracted object." The third paragraph addresses another quality found in Abstract Expressionism works: the painting's "harmony of color." And the final paragraph concludes by offering an explanation for the viewer's appreciation, which is based on reaction rather than on recognition.

Appreciation through Reaction:
de Kooning's *Untitled*

In the late 1800s, a trend moving toward Abstract Expressionism began with a move away from Realism. Artists of this period began to de-emphasize object and subject matter, and instead focused on the paint surface. More specifically, they were concerned with how the colors and textures of the paint created interest, merely giving an impression of the objects represented. This style fittingly became known as Impressionism. Cubist artists later incorporated Impressionist techniques, but they took the objects and further de-emphasized them by abstracting these objects, often to the point that they were not recognizable, focusing instead on such aspects of art as contrast, depth, surface, color, and plane. Because objects and realism had been relegated to such a minor role, it was a logical next step to ask why not eliminate them altogether? In the 1950s, Abstract Expressionism did just that. Willem de Kooning is recognized as a master of this style of painting. One of de Kooning's pieces—*Untitled*, oil on paper, mounted on board—is among the collection at the Hunter Museum of American Art in Chattanooga, Tennessee.

Like many of de Kooning's pieces, this work may not be completely freed from object, but it depicts such abstracted object that immediately recognizable forms cannot be discerned. As a result, the viewer is freed from personal associations. A sense of the beauty of the flowing human form can still be felt, however, in the flesh tone that meanders through the brighter forms in the painting, simulating human movement. Interestingly, de Kooning began his career as a figure and portrait painter; his appreciation for figure forms subtly influences this piece.

The lack of obvious subject matter in this piece allows the viewer to appreciate its harmony of color. It is dominated largely by cooler colors: blues and blue-greens. Even the pink has been cooled to a violet hue. These subdued cools are larger in form, but seem to drift in the background as a backdrop of clouds. The warm embers of color are smaller, but more intense, and they dance in the forefront. The intensity of these colors is emphasized by the energetic, seemingly erratic stroke. The combination of chaotic action with the subdued tones—as well as the forms that seem familiar but remain unrecognizable—create a mood that resembles waking from an uneasy dream.

Because no obvious object or theme is present, the viewer's appreciation of the piece is not determined by recognition, but by reaction. That being the case, every observer might react to the piece in a distinct manner. One observer might see de Kooning's painting as dreamy and sedated, while another might consider it chaotic and nerve-racking. Even the word that de Kooning selected to identify his painting is the result of a personal reaction. It is fitting that this piece is called *Untitled*; to title a piece is to assign meaning to it. No one—not even the artist who created the piece—can justifiably assign a meaning to a painting such as this, because each piece takes on its own meaning that will translate differently for each onlooker. It is this phenomenon that makes this painting a living thing. This is the beauty of Abstract Expressionism.

Major Museums in the East

Corcoran Gallery of Art

500 Seventeenth Street, NW
Washington, D.C. 20006
202.639.1700
www.corcoran.org

The Corcoran Gallery is unique among Washington's many museums. It is a private art museum, in fact the oldest in the city, and it is attached to the capital's only four-year art school, the Corcoran College of Art and Design. Its collection of American 19th- and early 20th-century art rivals those of the National Gallery and the Smithsonian, while its Corcoran Biennial exhibition of contemporary American art rivals that of the Whitney Museum in New York. Long considered the home gallery for Washington's own artists, the Corcoran has important holdings of nationally known local artists, such as Sam Gilliam and Gordon Parks, and supports emerging young American artists through its exhibition program.

The Corcoran has a complicated history. Its founder, William Wilson Corcoran, a prominent local banker and early collector of American painting and sculpture, often bought major works by artists he knew personally such as Frederic Church and Albert Bierstadt. In 1859, Corcoran commissioned James Renwick to design a public gallery to house his works. The landmark French Second Empire–style building was completed and opened to the public only after the Civil War, in 1874, by which time Corcoran had set it up as the independent Corcoran Gallery of Art. With some three hundred works of art by the end of its first year, the collection quickly outgrew the original building, which is now the Renwick Gallery of the Smithsonian Institution, near the White House.

The current and much larger museum, a beautiful marble Beaux Arts structure designed by Ernest Flagg, opened in 1897 several blocks away. The Corcoran College of Art has been operating since 1890, and the Biennial Exhibitions since 1907. A significant gift of European art by Senator William Andrew Clark in

PART TWO

1925 broadened the collection and led to an expansion of the building. A further expansion has been designed by contemporary architect Frank Gehry, but that project appears to be on hold indefinitely due to lack of funds.

Be sure to explore the Corcoran's 19th-century American paintings and its exhibitions of modern and contemporary art. The permanent collection holds such iconic American masterpieces as Church's *Niagara Falls*, Samuel Morse's *Old House of Representatives,* and Hiram Powers' *Greek Slave*, though the cream of the American collection is on tour through spring of 2007. In the meantime, a series of special exhibitions, and the Corcoran Biennial in Spring 2007, will fill the main galleries.

The French decorative arts and paintings, though not as well known, are also worth tracking down. The Corcoran's complex history is reflected in the quirky layout of the museum. The intrepid visitor exploring beyond the main central atrium galleries will be rewarded by an unexpected rotunda, a hemicycle, medieval stained-glass windows, and even a magnificent 18th-century French neoclassical furnished room, the Salon Doré from the hôtel de Clermont in Paris.

Both its commitment to contemporary art and its chronic underfunding have brought the Corcoran more than its share of controversy over the years. Much loved by local artists, the Corcoran often reflects the turmoil of Washington's cultural politics. The Corcoran's exhibitions are less predictable than other museums—even the permanent collection moves around a lot—so it is always a good idea to call or check the website to find out what is actually open or on display when planning a visit.

– Lawrence E. Butler

Freer Gallery of Art and Arthur M. Sackler Gallery

Smithsonian Institution
www.asia.si.edu
202.357.2700

Freer Gallery of Art
Jefferson Drive at Twelfth Street, SW
Washington, D.C. 20560

Arthur M. Sackler Gallery
1050 Independence Avenue, SW
Washington, D.C. 20560

The Smithsonian's Freer and Sackler Galleries are sibling institutions that together form one of the world's greatest collections of Asian art. Physically linked, each has a distinct character that complements the other.

The Freer is the oldest of the Smithsonian's independent art museums. Charles Lang Freer donated his extraordinary collection of Asian and American art to the nation in 1906, along with the neoclassical pavilion specially designed by George Platt to house it. Freer, a Detroit industrialist turned art connoisseur, developed a strong interest in Japanese and Chinese art through his own travels and the efforts of his advisors, who included the major taste-makers of the day. A close friend with the painter James Whistler, Freer came to regard Whistler and similar late-Impressionist painters as embodying the best of Western and Eastern arts combined. Freer's gallery, designed to educate the American public in aesthetics as well as to display his rare treasures, makes that point. Its twin strengths are its Asian art collection and the largest Whistler collection in the world, including his famous Peacock Room, painted for a London patron in 1876.

It would be hard to overstate the quality of the Freer's Asian collection. Its Chinese treasures include some of the finest Shang and Zhou Dynasty bronzes known, as well as fragile painted scrolls once owned by the Chinese emperors themselves. Japanese holdings include the largest collection anywhere of Hokusai paintings. An entire gallery is dedicated to Japanese painted screens, including such beloved examples as *Cranes* by Ogata Korin. Wonderful ceramics from China,

Korea, and Japan complement the paintings. The arts of India include major pieces of Buddhist stone sculpture and Hindu bronze work. The Islamic art collection, itself one of the finest in the world, includes famous examples of metalwork, glassware, ceramics, and illuminated manuscripts. The building was intended as a peaceful oasis, with its ample natural lighting and open central courtyard. By Freer's decree, works cannot be lent or borrowed to ensure that they are always available for study. Most of the collection is stored, however, due to works' fragility and the limited exhibition space. It pays to visit the Freer frequently, since exhibits rotate frequently. The great pieces do show up regularly, if you persevere.

In 1987 the Arthur M. Sackler Gallery opened next door, with an inaugural gift of some one thousand pieces from Sackler's extensive collections of Asian art. The two galleries are connected by a pan-Asian "Silk Road" exhibit, and share a staff. The Sackler, a mostly underground complex mirroring the National Museum of African Art next door, hosts loan shows and also exhibits its own holdings. It features an extensive collection of ancient Chinese bronzes and jades, and brings new areas of Asian art, such as ancient Persian and Southeast Asian art, to the Smithsonian. The Sackler is also a pioneer in collecting contemporary Asian art. At its opening, the Sackler managed to acquire the long-lost Vever Collection of Islamic arts of the book, which includes works that often form the nucleus of beautiful shows on the arts of Islamic Persia and India. Like the Freer next door, the Sackler's special exhibits change frequently, and are supported by a full range of cultural activities including music, film, and dance. Together, the Freer and Sackler Galleries have succeeded in putting the arts of Asia in forefront of Washington's cultural scene.

– Lawrence E. Butler

National Gallery of Art

Fourth Street and Constitution Avenue, NW
Washington, D.C. 20565
202.737.4215
www.nga.gov

At the northeast end of the Mall, architect I. M. Pei's great East Building of the National Gallery is a bookend to Maya Lin's Vietnam Memorial on the mall's south end—both are two of Washington's most significant 20th-century architectural works. But while Lin's work is somber and reflective, Pei's is soaring and confident—visitors enter through a broad-shouldered, H-shaped façade, made of Tennessee marble, into a skylit gallery dominated by 920 pounds of orange metal held aloft: an abstract and untitled "mobile" made in 1976 by Alexander Calder, a main player in the American abstract art movement. Using inventive systems of weights and counterbalances that move freely when suspended, Calder's mobile appears surprisingly light, like a flock of birds aloft.

The East Building connects by an underground passageway to its older partner, the West Building, where most of the collection is housed. Although young in comparison with other major museums—it was founded in 1937—the National Gallery can hold its own with any of the world's first-rate museums due to its extensive and varied collection. Of the more than 110,000 objects in the National Gallery's collection—the core of which was donated by nine founding benefactors—you should plan to see several highlights in particular. The first is the painting *Ginevra de' Benci* of 1474 by the Italian Renaissance artist Leonardo da Vinci. In this early portrait of a sixteen-year-old Italian girl, da Vinci presaged his status as one of the most significant High Renaissance painters through his realistic treatment of Ginevra's face and his innovative landscape setting. The significance of this work is reinforced by the fact that it is the only painting by da Vinci displayed in the Western hemisphere. Other works to see include the Spanish master El Greco's emotionally high-keyed religious paintings and Johannes Vermeer's delicate *Woman Holding a*

Balance. An American treasure is the 18th-century antecedent to *Jaws*, John Singleton Copley's *Watson and the Shark* (1778).

If the weather is good, head outside to the National Gallery Sculpture Garden, set at the west end of the complex. Here, you can sit among 17 sculptures by artists such as Joan Miró and Claes Oldenburg within a grove of flowering trees, shrubs, and flowers. The fountain doubles as a skating rink during the winter months. Since all the museums on the Mall are free, you can reenter as much as you like.

– Barbara E. Mundy and Alice G. Barrett

National Museum of African Art

Smithsonian Institution
950 Independence Avenue, SW
Washington, D.C. 20560
202.633.4600
www.africa.si.edu

The National Museum of African Art is one of Washington's great resources. It is one of the few museums in the world devoted solely to collecting and displaying African art, and its collection is very fine indeed. It was founded in 1964 as a private museum of traditional sub-Saharan African art. Its founder, diplomat Warren Robbins, housed the collection in a Capitol Hill townhouse that once belonged to Frederick Douglass. The Smithsonian recognized the significance of the collection, and acquired it in 1979. Since 1987, the collection has been housed in its own Smithsonian museum, part of the vast new museum complex built around and below the Smithsonian Castle and Enid Haupt Garden. The collection has expanded to encompass the entire African continent. Besides traditional masks and sculptures, the collection now includes archeological material, archival photographs, and works by contemporary African artists.

Visitors enter the museum through a domed pavilion in the Enid Haupt Garden, then descend into several levels of underground galleries centered around a deep atrium with a pool at the bottom. The building, designed by Jean Paul Carlhian, is surprisingly complex and not always easy to navigate. Galleries range in size from small to spacious on the main, "first" floor underground, with occasional skylights to brighten the dim lighting necessitated by the fragile organic materials. Special exhibitions are sometimes held in the largest space on the second level, visible from the lower foyer. It pays to explore, poking around corners and down staircases. The bookstore is an excellent resource, with music and audio-visual materials difficult to find elsewhere—but it might take special directions to find the bookstore in the first place. Do ask the guards.

The museum has a number of strengths, and rotates its many objects through frequently changing shows. The heart of the collection remains the sub-

Saharan masks and sculptures. Particularly notable works include the terra-cotta horseman from ancient Mali, a figured palace door and ritual bowls by the Yoruba sculptor Olowe of Ise, Central African masks, Kongo *nkisi* figures, a full-sized beaded effigy made for the court of King Njoya in Cameroon, and exquisite musical instruments. One long-time exhibit, "Objects of Daily Use," emphasizes the design qualities of such exquisitely made functional objects as chairs, pipes, and headrests. Another exhibit presents traditional ceramics as women's work and art. Other notable collections, not currently on exhibit, include royal brasses from Benin, presented to the Smithsonian by Joseph Hirshhorn, and the Lamb Collection of West African textiles. In 2006 the Museum will unveil its most spectacular new acquisition: the 525-piece Disney-Tishman African Art Collection, including several famous pieces of Afro-Portuguese ivory. The galleries change frequently; at this writing, much of the permanent collection has been taken off exhibit to prepare for the show of this new material.

The National Museum of African Art actively supports contemporary African artists, and uses several naturally lit galleries to showcase their work. Fans of contemporary art will enjoy seeing the work of these internationally sophisticated artists from all over the continent. Other museum resources include the Warren Robbins Library, the Eliot Elisofon photo-archives, and a conservation laboratory. The museum has a very active educational program to ensure that the community at large takes full advantage of this wonderful collection. The museum often mounts exhibitions aimed at children, and the galleries are often filled with their voices.

– Lawrence E. Butler

The Baltimore Museum of Art

10 Art Museum Drive
Baltimore, Maryland 21218
443.573.1700
www.artbma.org

Organized in 1914 by a group of citizen-collectors, the Baltimore Museum of Art (BMA) has a wide-ranging collection with particular strengths in American decorative arts and modern European art. The museum sits in a beautiful urban park setting on land donated by Johns Hopkins University in its Wyman Park on the southern edge of campus. The museum's core is a handsome neoclassical pavilion designed by John Russell Pope, architect of the National Gallery and the Jefferson Memorial in Washington, D.C. A new East Wing was added in 1982 and contains such amenities as a bookstore, special exhibition galleries, and a popular restaurant that opens onto the sculpture gardens. The East Wing was designed by Bower Lewis Thrower Architects (BLTA) of Philadelphia, the same firm that designed the striking West Wing for Contemporary Art, which opened in 1994. The West Wing's multistory gallery of metal, concrete, and glass offers large open spaces and a dramatic rotunda suitable for displaying the museum's growing collection of contemporary works.

The BMA's varied collection is the result of a number of notable donations. It reflects Baltimore's historic role as Maryland's largest city—in fact, one of the wealthiest, most cosmopolitan port cities of the South—and its strong cultural ties to Paris. The collection of American decorative arts is one of the best anywhere, and is particularly strong in its holdings of Baltimore furniture from the 18^{th} and 19^{th} centuries. Period rooms on several floors come from six historic Maryland houses. The collection of old master paintings, in the recently refurbished Jacobs Wing, is enriched with a number of small animal bronzes by 19^{th}-century French artist Antoine-Louis Barye. Outside, the terraced Wurtzburger and Levi Sculpture Gardens contain significant European and American metal sculptures of the 20^{th} century, and make a graceful transition between the museum and its surrounding park.

PART TWO

The BMA is perhaps best known for its great Cone Collection of Modern Art, a spectacular group of early modern works, mostly from France. The collection features paintings and sculptures by Henri Matisse, notably his *Large Reclining Nude* of 1935. These works were collected in Paris by Baltimore sisters Etta and Dr. Claribel Cone, and donated to the BMA in 1949 by Etta Cone "for improving the spirit of appreciation for modern art in Baltimore." The collection is enriched with significant works by Pablo Picasso, Georges Braque, and the great French Impressionists and Post-Impressionists; some of the works were once owned by Gertrude Stein, who was close friends with the sisters. A recent and highly praised renovation of the Cone galleries added a small room filled with their personal effects, giving you a sense of what sort of furnishings and bric-a-brac collectors of early modern art have enjoyed in their own homes.

Other strengths of the BMA include an extensive collection of old master prints and drawings, a large collection of beautiful late antique mosaics from the Antioch excavations of the 1930s, and one of the nation's earliest major museum collections of African art. The BMA has long been a promoter of African-American art.

Taken together, Baltimore's two great art museums, the Walters and the BMA, complement each other remarkably well. Both have very strong focused collections that have almost no overlap, but together encompass the world, from deep antiquity to the present day.

– Lawrence E. Butler

The Walters Art Museum

600 North Charles Street
Baltimore, Maryland 21201
410.547.9000
www.thewalters.org

The Walters Art Museum is the jewel of Baltimore's historic city center, the Mt. Vernon Square neighborhood. It was founded by William Walters, one of the great 19th-century banking and railway magnates, and his son Henry Walters. The collection still bears their strong stamp, with its remarkable holdings of European decorative arts, luxury books and manuscripts, and old master paintings, acquired on a massive scale in Europe from the 1860s through the 1930s. One of the largest private collections in America when Henry Walters left it to the city of Baltimore in 1931, it has grown into one of America's great comprehensive museums, housing the finest collection of ancient and medieval art in the Mid-Atlantic region, along with a wealth of European paintings and decorative arts from around the world. The Walters has recently become a national leader in the innovative display of art in context, with extensive use of multimedia and period-style galleries.

The "palazzo" that Henry Walters had built for his art is the core of the museum today, a handsome Italian Renaissance building fronting Washington Square. Opened in 1909, the building was modeled on a Genoese Renaissance palace, and features a beautiful arcaded central court with grand stairs and galleries around it on two floors. Today it showcases two of the museum's strengths: decorative arts and European paintings. On the first floor are galleries for decorative arts of the European Renaissance, Baroque, and early modern period, with objects ranging from arms and armor to Fabergé eggs. In 2005, the museum opened "The Palace of Wonders," a series of rooms arranged as they might have looked in Flanders and Holland in the 17th century. Wall paintings are displayed along side "wonders" of the natural world, fine objects of European craftsmanship, and imported exotica from the Americas, Africa, and the Dutch East Indies, recreating the way Northern Baroque art would have originally been displayed in aristocratic homes.

PART TWO

Upstairs, the second-floor galleries house an excellent collection of Italian Renaissance and Baroque paintings hung in richly colored settings reminiscent of European palace galleries.

A new wing opened in 1974 to house the ancient, medieval, and 19th-century art, as well as special exhibition space and an auditorium that hosts an active music program. The second floor displays an extensive collection of ancient Egyptian, Near Eastern, Greek, and Roman art. In 2001 the building reopened after extensive renovations with some of the most exciting medieval art galleries in the country on the third floor. The Walters' famous collections of medieval manuscripts, ivories, sculptures, and icons have been entirely integrated in the displays, with the manuscripts made even more accessible through the use of touch-screen kiosks. Several small medieval period rooms have been created. The icon in its many forms is the unifying theme of the floor, highlighting the museum's excellent Byzantine and Russian holdings. At the very center of this wing is the Walters' new collection of Ethiopian Coptic icons and church treasures, the most significant collection of Ethiopian art outside of Ethiopia. The museum's Islamic art collection interacts with the medieval art in interesting ways. The fourth floor features a famous collection of mostly French 19th-century art, including a period-style Orientalist gallery with famous "exotic" paintings by Gérôme, Delacroix, and Alma-Tadema.

A third building, the Hackerman House, a restored mansion on Mt. Vernon Square, opened in 1991 for the display of the museum's Asian art collection. Most of the objects here reflect the Walters' interest in decorative arts, including porcelain, ivory, and small metalwork. One recent notable addition is a collection of Thai Buddhist bronzes. A restaurant connects the Hackerman House to the palazzo, and completes the museum complex.

– Lawrence E. Butler

Museum of Fine Arts, Boston

Avenue of the Arts
465 Huntington Avenue
Boston, Massachusetts 02115
617.267.9300
www.mfa.org

Boston's Museum of Fine Arts (MFA) holds a spectacular collection, capable of competing with museums in New York, Paris, or any of the better-known art meccas. It has a passion for expansion: opening first in 1879 on Copley Square, the MFA moved to bigger quarters on Huntington Avenue in 1909, and later to its current location. Today it is the largest museum in New England and is undergoing yet another expansion: a project that aims to transform the way visitors to the MFA see the art with new spaces designed to encourage a heightened interaction between the viewer and the works of art themselves.

The oldest highlights in the MFA's collection are certainly its works from the age of pyramids in Egypt, the product of excavations carried out in Giza beginning in 1902. Unlike practices today, the museum was allowed to export a huge number of works, and today the collection is probably the best outside of Egypt itself. Its collection of Mayan vases, a great indigenous art form, is extraordinary as well.

Other highlights lie in its European art galleries. One is the moody, color-drenched *Slave Ship,* one of J.M.W. Turner's most celebrated paintings. In it, the British artist combines his fascination with the sublime along with his extraordinary use of intense color and light to capture an actual historical event. A nightmarish scene unfolded in 1873 when a slave ship was caught in a storm. Since insurance was paid only when slaves died at sea, not from shipwreck, the heartless captain pitched his human cargo overboard. In this poignant painting by Turner, the violent merging of sea and sky leaves viewers with the feeling that they have just witnessed this horrifying event first-hand.

Another masterpiece is Paul Gauguin's enormous Post-Impressionist work *Where Do We Come From? What Are We? Where Are We Going*? of 1897. This painting, which Gauguin considered an artistic culmination, exhibits his theory of

"primitivism," a discovery of a higher truth through a rejection of Western culture. He bases his fantasy of Eden, showing the phases of human life, in Tahiti, where he lived for years.

When visiting the MFA, make sure to visit the Japanese Zen Garden, located outside on the west corner. It is the perfect respite for the weary sightseer and acts as a great escape from the city's crowded tourist spots.

– Barbara E. Mundy and Alice G. Barrett

Brooklyn Museum

200 Eastern Parkway at Washington Avenue
Brooklyn, New York 11238
718.638.5000
www.brooklynmuseum.org/

If you think Brooklyn is somewhere mysterious, just hop onto a number 2 or 3 subway train, and it will whisk you right to this museum's front door. The door faces Eastern Parkway, one of city- and park-planner Frederick Law Olmsted's grand urban avenues. At one side of the museum is the Brooklyn Botanic Garden with an exquisite cherry tree grove, a Japanese garden, and glorious greenhouses; the garden may be visited with a combination museum-garden ticket. Just beyond the garden is the art moderne Brooklyn Public Library with a grand gold-trimmed façade. And the museum itself offers enormous pleasures to those interested in the arts of the Americas, Asia, and Africa.

The museum's entrance since 2004 has been a glass-canopied construction by the architects Polshek and Partners. The glass canopy leads into a spacious lobby that extends the museum's main domed structure, which opened about a century earlier in the design of Beaux Arts–style masters McKim, Mead, and White. Ask for a floor plan and plot your journey to arts of Africa, the Pacific, and the Americas on the first floor; to Islamic arts and those of Asian nations on the second floor; to Assyrian reliefs and one of North America's premier collections of Egyptian art on the third; to American decorative arts on the fourth; and to a grand miscellany on the fifth floor, including a gallery of sculpture by Rodin, storage collections visible to visitors, early films by Thomas Alva Edison, videos of the image of black people in art, and a spectacular collection of American paintings from John Singleton Copley to Robert Colescott. Among the paintings, you will see works by Albert Bierstadt, Thomas Eakins, John Singer Sargent, Georgia O'Keeffe, David Smith, and many other significant artists. The museum also houses several European old master paintings.

The museum's curators are sensitive to Brooklyn's history and its multi-ethnic population. The British-colonial era is represented in the display of the entire ground

floors of two 18th-century houses and many decorative objects of the period including beautiful silver, furniture, and ceramics. The 19th-century displays include an Orientalizing smoking room from the Rockefeller family's house in Manhattan and an art deco study taken from a demolished residence. Religious and secular Spanish-colonial arts usually have bilingual labels. Handsome Native American objects are on display, as are Korean arts, which are often neglected elsewhere in favor of those from China and Japan, though those countries' works are also conspicuous here. African and African-American arts have long received attention in this museum. Islamic and South Asian cultural artifacts are prominent, too, including beautiful sculpture and metalwork. But the museum has been most famous since it opened in 1906 for its Egyptian and American collections, for its innovative children's educational efforts, and for having one of the earliest and best museum shops in the nation. Adding to its prestige, the museum's art school has had famous artists on its faculty.

A café offers refreshments. You'll need a lunch or coffee break because it takes hours to admire the riches of this palatial museum. If you visit on the first Saturday of each month, you can stay until 11 PM, enjoying music, refreshments, and the lively company of young singles.

– Carol H. Krinsky

The Frick Collection

One East Seventieth Street
New York, New York 10021
212.288.0700
www.frick.org/

To visit the Frick Collection is to reenter the world of New York's Golden Age, when the super rich modeled themselves after Renaissance princes, building urban palaces and amassing spectacular art collections. The collection is housed in a 1913 mansion that was part of Millionaire's Row, a string of equally elegant houses that once stretched along Fifth Avenue. It was built for Henry Clay Frick, who made his money in steel in Pittsburgh, and cost $5 million—a fortune at the time. Frick was avid collector, and he designed his mansion to accommodate his large collection of paintings and other works of art, always with the intention of leaving it to the public. After his wife's death in 1931, the Frick's home was converted into a museum, and in 1935 the Frick Collection opened to the public. The Living Hall still looks the way it did when the Fricks lived in the house, and the collection reflects the specific tastes of Frick himself, who favored the old masters, particularly Rembrandt.

Thus, the Frick Collection's gems are undoubtedly the works of German and Dutch painting. Hans Holbein's sensitive *Portrait of Sir Thomas More* (1527), the great English humanist scholar who was Holbein's host when he first visited the court of Henry VIII, hangs in the living hall beside the fireplace, just as Frick placed it. Rembrandt is represented by bookend self-portraits, one done when he was an ambitious young artist, the other, when he was an old man staring down death in 1658. His painting *The Polish Rider* is also in the collection. Only about three dozen paintings are know to have been painted by Johannes Vermeer, and Frick acquired three of them, including the exquisite *The Laughing Girl* (1655–1660), with its light-filled interior and luminous coloring.

The permanent collection also includes more than a thousand works of art from the Renaissance to the late 19th century—not all of them are on view, but many of the best paintings by great European artists are. You may see works by Titian,

PART TWO

Tintoretto, El Greco, Velázquez, Hals, van Dyck, Tiepolo, Greuze, and Goya, among others. These paintings overshadow the antique French furniture and porcelains and Oriental rugs that the Fricks also collected.

<div align="right">– Barbara E. Mundy and Alice G. Barrett</div>

Solomon R. Guggenheim Museum

1071 Fifth Avenue at Eighty-Ninth Street
New York, New York 10128
212.423.3500
www.guggenheim.org/

Visitors flock to the Guggenheim Museum to see its unusual round building as much as to see the art inside. Frank Lloyd Wright designed the building for Guggenheim, who started collecting non-objective (abstract) painting in 1939 and wanted a museum in which to house his collection. From 1943 until his death in 1959, just before the museum opened, Wright worked on a building of unprecedented shape and plan, one that would require visitors to take an elevator to the top floor and descend a sloping spiral winding around an open cylindrical core. Visitors would see the works in a prescribed sequence and understand the relationship of neighboring pictures while also being able to look across the core to view those opposite, above, and below. The central skylit space that Wright designed remains exciting to visit, but a reading room by Richard Meier and additional galleries in a tower designed by Gwathmey, Siegel and Associates (1992) allow visitors the option of pausing in rectangular rooms on several levels. These additions were built to house later acquisitions and to display the permanent holdings when the rotunda is devoted to traveling exhibitions.

The Guggenheim's collection starts chronologically with a landscape of 1867 by the French painter Camille Pissarro, but most of the museum is devoted to 20th-century art. It is hard to think of an "ism" that is not represented here, from Arte Povera to Art Brut, from the Bauhaus to Pop, Suprematism, Post-Minimalism, and more. The artists included include stars such as Paul Klee, Wassily Kandinsky, Kazimir Malevich, Joan Miró, Isamu Noguchi, Alberto Giacometti, and Andy Warhol. Women artists are represented, too—Cindy Sherman, Eva Hesse, Barbara Kruger, and Germaine Richier, among others. Picasso's work can be seen, as can paintings by Jackson Pollock and Robert Rauschenberg, and sculpture by Claes Oldenburg and John Chamberlain, but less famous artists also offer significant pleasures. Art

students, for instance, take special interest in the work of Bauhaus teachers, such as Josef Albers and Laszlo Moholy-Nagy.

At the Guggenheim, you can usually see spectacular temporary exhibitions. In recent years they have featured motorcycles, works of historic and modern art from Brazil, the word-images of Jenny Holzer, and user-friendly pictures by Norman Rockwell. A café and shop provide places in which to catch your breath after a stroll down the spiral.

– Carol H. Krinsky

The Metropolitan Museum of Art

1000 Fifth Avenue at Eighty-Second Street
New York, New York 10028-0198
212.535.7710
www.metmuseum.org/

In *From the Mixed up Files of Mrs. Basil E. Frankweiler,* two runaways end up living in the Met, lodging in period rooms while dodging the guards. It's easy to see why this fictional work is so believable: the Met has a permanent collection of over two million works in two hundred rooms linked with miles of corridors. It's a universal museum, containing almost every category of art in almost every known medium, and offers the ultimate art-viewing experience. Taken as a whole, the Met's collection is overwhelming.

Since moving in is not an option, it's best to see a few highlights on a first visit. For instance, the Met has its own Egyptian temple, the Temple of Dendur, dating from 15 B.C.E., which was given to the Met when the temple's original site was flooded during the construction of the Aswan dam. The Met has even recreated the environment in which the temple was found—complete with papyrus plants and coordinating statues. The newly installed Classical Galleries contain the spectacular Kouros figure from Attica of c. 590–580 B.C.E., a pristine example of Archaic Greek style. The European paintings include the tender painting of a *Young Woman with a Water Pitcher* (c. 1662) by Johannes Vermeer, and nearby is a huge selection of Rembrandt's masterful portraits of friends, lovers, and patrons. A strong suit is French Impressionism, with the water lilies that Claude Monet captured on different times and days lining the walls of one room.

A little oasis where you can sit down is the Charles Engelhard Court, a glassed-in garden; much of its color comes from the extraordinary stained glass windows, created by Louis Comfort Tiffany of Tiffany and Company fame. The courtyard is flanked by a Federal-style building (yes, a building—it's the façade of Martin E. Thompson's Wall Street Bank of 1822–1824) that the Met salvaged to act as gateway to the museum's American Wing. Well-known works of American

painting, like Gilbert Stuart's *Portrait of George Washington* and Winslow Homer's *The Gulf Stream*, are within.

While it may be near impossible to touch on all of the Met's highlights, you'll benefit from some prior research and a plan of the areas you want to explore; the website is an excellent resource for planning. The Met's founders aimed to bring art to the people—and while the early collection mainly reflected what wealthy New Yorkers themselves collected, it is now a much larger global emporium. Do note that the admission prices are "suggested," and for as little as a nickel at the door, you too can share in the artistic wealth.

<div align="right">– Barbara E. Mundy and Alice G. Barrett</div>

The Museum of Modern Art

11 West Fifty-Third Street
New York, New York 10019
212.708.9400
www.moma.org/

Without a doubt, the Museum of Modern Art (MoMA) has the greatest collection of 20th-century Western painting and sculpture in the United States. It is difficult to choose the best, most significant works in the MoMA's collections, but any visitor to MoMA should not miss Vincent van Gogh's famed *Starry Night* of 1889. In its expressive color and brushstrokes, van Gogh's work departs from the earlier Impressionist commitment of truth to nature in favor of agitated feeling and powerful color. In doing this, *Starry Night* was the foundation for all consequent Expressionist painting. Another highlight is Pablo Picasso's *Les Demoiselles d'Avignon* (1907), which breaks radically with the traditional idea of compositional beauty. The origins of Cubism can be seen in this depiction of five naked prostitutes brutally composed of flat, splintered planes. And Marcel Duchamp's *Bicycle Wheel*, a metal bicycle wheel mounted upside-down on a painted kitchen stool, is the first in Duchamp's series of "readymades," alterations of common, everyday objects that force viewers to raise fundamental questions about the definition of art and art making.

The MoMA's building is the product of a recent renovation by the Japanese architect Yoshio Taniguchi, and is perhaps most notable for the remarkable views afforded onto the second-floor atrium, where Barnet Newman's 25-foot *Broken Obelisk* (1963–1969) balances precariously in the center of the floor, facing off against one of MoMA's early masterpieces, Claude Monet's *Water Lilies* of c. 1920. On the fifth and fourth floors, the permanent painting galleries offer a loosely chronological display of the unfolding of modernist art, up to about 1970. Here, one can see the progression of all the great 20th-century "isms": Cubism, Futurism, Suprematism, Constructivism, Surrealism, Abstract Expressionism, and Minimalism, with canonical examples of each.

PART TWO

MoMA's entire collection numbers about 150,000 paintings, sculptures, drawings, prints, photographs, architectural models and drawings, and design objects dating back to the 1880s. Fortunately for you, not all of them are on display at any one time, but some of the best works usually are. MoMA also owns approximately 22,000 films, which are regularly screened for the public. While MoMA does have rotating exhibitions, which allow it to show the work of living artists, the museum has recently affiliated itself to P.S.1, a contemporary-arts center in Queens, to bolster its support of new art and artists.

As one of Manhattan's temples of art, MoMA is usually quite crowded, especially on Friday nights, when a pay-what-you-wish policy attracts thrifty art-lovers, and on weekends. Monday mornings are a good time to go if you want a more contemplative experience.

– Barbara E. Mundy and Alice G. Barrett

Whitney Museum of American Art

945 Madison Avenue at Seventy-Fifth Street
New York, New York 10021
800.WHITNEY
www.whitney.org/

Marcel Breuer, the principal designer of the Whitney Museum, didn't want his museum to be mistaken for an office building or a place of light entertainment. To make sure it would look like a serious cultural institution even on its small lot of 100 by 125 feet, he and his partner, Hamilton P. Smith, created a dramatic granite-coated reinforced concrete building in which the upper floors cantilever over the street-level entrance. Look down as you enter across a modern-day drawbridge to see the lower levels and sculpture court. There and on the upper floors are painting, sculpture, drawings, photographs, and prints by American artists, most dating from about 1900 to the present.

Seven hundred of its original acquisitions were donated by its founder, Gertrude Vanderbilt Whitney. An energetic and generous patroness of artists, she assisted members of the early 20th-century group "The Eight," which included Robert Henri, and she was a guiding figure in the Armory Show of 1913, which is often credited with introducing modernism to the United States. Gertrude Whitney created the first Whitney Museum downtown but as the art scene moved north, so did the museum, until the present one opened in 1966. In recent years, prominent architects Michael Graves and Renzo Piano have been enlisted to design additional space, but nothing so far has been financed or finally approved.

The Whitney's collections go well beyond pictures by "The Eight," and include works by Marsden Hartley, Edward Hopper (whose widow donated 2,500 items), Stuart Davis, Georgia O'Keeffe, Jackson Pollock, Willem de Kooning, Andy Warhol, Louise Bourgeois, and every great name in between. The architect designed several spacious, tall galleries to accommodate the enormous abstractions of the 1950s and 1960s, while other galleries are well suited to smaller paintings that Gertrude Whitney might have hung in her home.

PART TWO

The museum sponsors biennial exhibitions of contemporary work and maintains a website, Artport, with changing displays of electronic art. An active program of lectures, concerts, and performances includes presentations by critics, artists, scholars, and writers, and special programs are offered in the galleries in connection with changing exhibitions. The "Seminars with Artists" series allows members of the public to hear presentations by artists, including those whose works are displayed in the Biennial, while salon-style dialogues allow you to observe actors on the arts scene conversing with curators, other artists, and writers. "Architecture Dialogues" is another series open to the public.

If you have a serious interest in a career in the arts, you may want to investigate the Whitney's Independent Study Program, internships, and other training opportunities.

– Carol H. Krinsky

Philadelphia Museum of Art

Twenty-Sixth Street and the Benjamin Franklin Parkway
Philadelphia, Pennsylvania 19130
215.763.8100
www.philamuseum.org/

Conveniently nestled between New York City and Washington D.C., Philadelphia is home to several world-renowned museums, not the least of which is the Philadelphia Museum of Art (PMA). Overlooking downtown Philadelphia and the Schuylkill River, the 19th-century neoclassical building is a city landmark made famous by Sylvester Stallone's trip up the majestic façade staircase in *Rocky*.

The internationally reputed collection of almost 225,000 works of art is distinguished by the largest collection of Constantin Brancusi sculptures in the world, as well as the most complete collection of the work of famed Dada artist Marcel Duchamp. The Duchamp collection boasts several of his "readymade" artworks, including *Bicycle Wheel, Bottle Rack*, and the infamous and controversial *Fountain*. Duchamp's enigmatic and shocking *Given 1: The Waterfall 2: The Illuminating Gas* is a unique installation that encourages you to break museum rules by touching and interacting with the work. The museum's impressive modern collection also includes Paul Cézanne's canonical *Large Bathers* and Jackson Pollock's *Male and Female*, a totem image from the 1940s that unifies Cubism, Synchronism, Surrealism, and Abstraction into a cohesive representation of the human genders.

While these and other monumental and influential works belong to the 19th- and 20th-century collections on the first floor, the second floor of the PMA's collection offers excellent examples of earlier and non-Western works. The PMA proclaims itself to be the only museum in the United States to display a reconstructed Indian temple. The 16th-century temple is rebuilt within a second-floor gallery, and welcomes you into its quiet and beautiful sanctuary. In addition to this fantastic structure, you may also walk the cloisters of a medieval Abbey, meditate in a Buddhist temple, and enjoy a ceremony in the Japanese Tea House.

PART TWO

The PMA is distinguished in the United States for its diverse and integrated collection of art that reflects a global view of the art historical past and present. In addition to the vast collection of sculpture and painting, the museum also owns an impressive body of furniture, ceramics, glassworks, and textiles from around the globe.

The museum is closed on Mondays, and on Fridays it stays open until 8:45 PM when it sponsors "Art After 5," an eclectic mix of art and entertainment offering international music played live in the Great Stair Hall. Sunday typically finds the museum busy with students and families due to the pay-what-you-wish policy, though the museum rarely feels crowded. The museum also offers a self-guided audio tour and docent-guided tours throughout the day to orient you to its comprehensive collection.

– Sarah M. Iepson

Chrysler Museum of Art

245 West Olney Road
Norfolk, Virginia 23510-1587
757.664.6200
www.chrysler.org/

Originally founded in 1939, the Chrysler Museum is named for automobile heir Walter P. Chrysler, Jr., whose 1971 gift of his collection to the city of Norfolk led to the renaming of the Norfolk Museum of Arts and Sciences after him. Chrysler's collection, one of the largest collections of modern painting and sculpture in the United States, consists of pieces he purchased from artists he met while touring Europe in the 1930s. These artists include Picasso, Braque, Gris, Matisse, Leger, and other avant-garde artists who were living in Paris.

The Chrysler Museum features European and American collections in sculpture, painting, and photography, as well as three historic houses and an internationally famous glass collection. In the European collection, look for works by two of the best known Impressionists, Degas and Renoir. In Renoir's *The Daughters of Durand-Ruel*, notice the soft, feathery brushstrokes and clear, vibrant colors typical of Impressionism. Among the American works, you'll find a typical Mary Cassatt piece, *The Family*, featuring a quiet moment shared by a mother and her children.

When you reach the photography exhibits, you'll recognize some—Abraham Lincoln with his son Tad, or Joseph Stalin seated in the Kremlin. For others, though, you might not recognize the face, but you might be familiar with their work. For example, you'll see an 1856 photograph of Gioacchino Antonio Rossini. While you might not recognize Rossini's face or his name, you'll almost certainly know one of his most famous musical compositions—the overture from the *William Tell* opera, more commonly known as the Lone Ranger's theme song.

Other highlights include Gianlorenzo Bernini's *Bust of the Savior* (1679–1680). This was Bernini's last work, carved by his own hand at the age of 80 in spiritual preparation for his imminent death. As you move your eyes across the large panel of Thomas Cole's *The Angel Appearing to the Shepherds* (1833–1834), you'll

notice several scenes: the vision of the angel on the left; the scattered flock of sheep near the center; the three shepherds on the right; the ancient ruins above them; and on the far right, the guiding star above the events in Bethlehem. John Northwood I's *Milton Vase* (1878) was among several of Northwood's vases that received wide acclaim at the Paris World's Fair in 1878. Executed in the demanding Roman cameo technique, it illustrates a scene from John Milton's *Paradise Lost*—with Adam and Eve on one side, and the angel Raphael on the other. Henri Matisse's *Bowl of Apples on a Table* (1916) is a work typical of the Fauves and depends on the bold use of colors. Mark Rothko's *Untitled* (1949) was completed early in his career, and is typical of Rothko's large-scale, abstract paintings featuring luminous rectangles of colors that seem to float in space.

– Scott Douglass

Other Museums in the East

Connecticut

Bridgeport

Housatonic Museum of Art
Burt Chernow Galleries
900 Lafayette Boulevard 06604
203.332.5052
www.hctc.commnet.edu/artmuseum/
Bridgeport's HMA collection includes works by
such master artists such as Rodin, Picasso,
Matisse, Miró, and Chagall. The HMA also
presents lectures, programs, and changing
exhibitions in the Burt Chernow Galleries.

Farmington

Hill-Stead Museum
35 Mountain Road 06032
860.677.4787
www.hillstead.org
Hill-Stead houses Alfred Atmore Pope's prized
collection of French Impressionist paintings plus
a wide variety of sculpture, prints, ceramics,
textiles, and furnishings.

Greenwich

Bruce Museum of Arts and Science
One Museum Drive 06830
203.869.0376
www.brucemuseum.org/
The Bruce Museum's collection includes more
than 15,000 objects in fine and decorative art,
featuring American and European paintings and
sculpture of the 19th and 20th centuries.

Hartford

Artworks Gallery
233 Pearl Street 06103
860.247.3522
www.artworksgallery.org/
This regional museum features the works of
contemporary local and regional artists.

Real Art Ways
56 Arbor Street 06106
860.232.1006
www.realartways.org/
Real Art Ways promotes contemporary arts
through programs in visual arts, live arts, and
film and video.

Wadsworth Atheneum Museum of Art
600 Main Street 06103
860.278.2670
www.wadsworthatheneum.org/
Founded in 1842 by Daniel Wadsworth, the
Wadsworth Atheneum is the oldest public art
museum in the country. Its permanent
collection includes more than 45,000 works of
art, featuring works from the Hudson River
School Also among the collection are works
from six centuries of European art.

Middletown

Davidson Art Center
Wesleyan University
301 High Street 06459-0487
860.685.2500
www.wesleyan.edu/dac/
The Davidson collection features a wide range
of works on paper, including prints,
photographs, drawings, and paintings.

New Britain

New Britain Museum of American Art
56 Lexington Street 06052-1412
860.229.0257
www.nbmaa.org/
This museum's collection includes more than
5,000 works of American art, including oil
paintings, watercolors and pastels, sculptures,
and photographs. Represented artists include
Trumbull, Peale, Stuart, Cassatt, O'Keeffe,
Warhol, and Segal.

New Canaan

Silvermine Guild Arts Center
1037 Silvermine Road 06840
203.966.9700
www.silvermineart.org/
Silvermine exhibits the works of contemporary
local and regional artists, featuring artists from
nine northeastern states. Silvermine also hosts
exhibits of nationally recognized artists.

New Haven

Yale University Art Gallery
1111 Chapel Street 06520-8271
203.432.0600
www.yale.edu/artgallery/
Housed in a building designed by American
architect Louis Kahn, this campus gallery offers

a collection of a wide range of art from around the world.

New London

Lyman Allyn Art Museum
625 Williams Street 06320
860.443.2545
www.lymanallyn.org/
This museum's permanent collection includes more than 15,000 objects includes paintings, sculpture, drawings, prints, furniture, decorative arts, and American art from the 18th through 20th centuries.

Old Lyme

Florence Griswold Museum
96 Lyme Street 06371
860.434.5542
www.flogris.org/
Known as the Home of American Impressionism, this museum has a strong connection to the Lyme Art Colony and specializes in American art.

Lyme Academy of Fine Arts
84 Lyme Street 06371
860.434.5232
www.lymeacademy.edu/
Throughout the year, Lyme Academy offers a variety of exhibitions featuring the works of its students, faculty, and visiting artists.

Ridgefield

Aldrich Contemporary Art Museum
258 Main Street 06877
203.438.4519
www.aldrichart.org/
The Aldrich is a regional facility that presents contemporary art exhibitions and programs.

Stamford

Stamford Museum and Nature Center
Leonhardt Galleries
39 Scofieldtown Road 06903
203.222.1646
www.stamfordmuseum.org/
The highlights of this museum's exhibits include collections of American art and Native American art.

Storrs

Contemporary Art Galleries: Storrs and Stamford
University of Connecticut
830 Bolton Road 06269
860.486.1511
www.sfa.uconn.edu/cag/cag.html
CAG's galleries present exhibits featuring a wide range of topics, including architecture, design, photography, performance, music, film, video, and digital media.

William Benton Museum of Art
School of Fine Art
University of Connecticut
245 Glenbrook Road 06269
860.486.4520
www.benton.uconn.edu/
With excellent resources, this campus gallery offers an extensive collection of art from around the world.

Delaware

Dover

Biggs Museum of American Art
406 Federal Street 19903
302.674.2111
www.biggsmuseum.org
The Biggs Museum exhibits an extensive collection of 18th-century decorative arts.

Newark

University Galleries
University of Delaware
Old College and Mechanical Hall
114 Old College Drive 19716-2509
302.831.8037
www.museums.udel.edu/
The permanent collection at this university facility includes pre-Columbian pottery and American Inuit drawings, as well as works ranging from Russian icons through contemporary American photography. A highlight is the Paul R. Jones Collection of African-American art.

Wilmington

Delaware Art Museum
2301 Kentmere Parkway 19806
302.571.9590
www.delart.org/

The Delaware Art Museum's collection features American art from the 19th to the 21st centuries, as well as the English Pre-Raphaelite works from the mid-19th century.

Delaware Center for the Contemporary Arts
200 South Madison Street 19801
302.656.6466
www.thedcca.org/
This regional facility presents exhibits by regionally, nationally, and internationally recognized artists.

Winterthur

Winterthur Museum and Country Estate
Route 52 Kennett Pike 19735
800.448.3883
www.winterthur.org
Associated with the du Pont family, this museum houses an extensive collection of objects made or used in America between 1640 and 1860. The series of galleries exhibits furniture, textiles, needlework, paintings, prints, and works in ceramics, glass, and metal.

District of Columbia

Corcoran Gallery of Art
500 Seventeenth Street, NW 20006-4840
202.639.1700
www.corcoran.org/
See description on page 37.

Dumbarton Oaks
1703 Thirty-Second Street, NW 2007-2961
202.339.6401
www.doaks.org/
Affiliated with Harvard University, this facility houses an extensive collection of Byzantine and Pre-Columbian art. It also houses rare and modern books related to the history of gardens. Although the museum is currently closed for renovations, it is scheduled to reopen in 2007; consult the website for information about its reopening. The gardens are open to the public.

Freer Gallery of Art
Smithsonian Institution
Jefferson Drive at Twelfth Street, SW 20560
202.357.3200
www.asia.si.edu/
See description on page 39.

Georgetown University Art Galleries
Walsh Building
1221 Thirty-Sixth Street NW 20057

202.687.7452
www.georgetown.edu/departments/amth/studio
artsgallery_top.html
These campus galleries offer exhibits from students, faculty, and artists from around the world.

The Kreeger Museum
2401 Foxhall Road, NW 20007
202.337.3050 877.337.3050
www.kreegermuseum.com/
The Kreeger's collection features paintings and sculpture by European, African, and American artists.

Hillwood Museum and Gardens
4155 Linnean Avenue, NW 20008
877.445-5966 202.686.5807
www.hillwoodmuseum.org/
Founded by Marjorie Merriweather Post, the Hillwood offers exhibits of items she collected from around the world: ceramics, decorative arts, furniture, glass, metalwork, paintings, and textiles.

Hirshhorn Museum and Sculpture Garden
Smithsonian Institution
Independence Avenue at Seventh Street, SW 20013
202.357.3091
hirshhorn.si.edu/
The Hirshhorn is the Smithsonian's museum of international modern and contemporary art and displays works by artists such as Louise Bourgeois, Constantin Brancusi, Arshile Gorky, and Donald Judd.

Howard University Gallery of Art
500 Howard Place, NW 20059
202.806.7234
www.howard.edu/CollegeFineArts/GALLERy_F
INAL/GalleryofArt.html
The collections at this university gallery feature African and African-American art, as well as art from the Renaissance and Baroque periods.

National Gallery of Art
Third and Ninth Streets at Constitution Ave, NW 20013
202.737.4215
www.nga.gov/
See description on page 41.

National Museum of African Art
Smithsonian Institution
950 Independence Avenue, SW 20560-0708
202.357.4600

www.nmafa.si.edu/
See description on page 43.

National Portrait Gallery
F Street at Eighth Street, NW 20560
202.633.1000
www.npg.si.edu/
As part of the Smithsonian Institution, the
National Portrait Gallery houses the nation's
collection of portraits of many of its most
influential citizens, including presidents and
other historical figures.

Phillips Collection
1600 Twenty-First Street, NW 20009
202.397.7328 800.551.7328
www.phillipscollection.org/
The Phillips Collection opened in 1921 and
includes works by Impressionists (van Gogh,
Monet, Degas, and Cézanne) and by such
American artists as Homer and O'Keeffe. A
highlight is Renoir's *Luncheon of the Boating
Party.*

Arthus M. Sackler Gallery
Smithsonian Institution
1050 Independence Avenue, SW 20560
202.357.3200
www.asia.si.edu/
See description on page 39.

**Smithsonian American Art Museum and
Renwick Gallery**
Seventeenth Street and Pennsylvania Avenue,
NW 20003
202.633.1000
americanart.si.edu
The SAAM's collection features a wide variety
of American art: colonial portraits, 19th-century
landscapes, American impressionism, 20th-
century realism and abstraction, photography,
prints, drawings, sculpture, and decorative arts.
The Renwick Gallery houses a collection of
contemporary American craft.

The Textile Museum
2320 South Street, NW 20008
202.667.0441
www.textilemuseum.org/
This museum features an extensive collection of
non-Western textile arts. Among its collection
are Oriental rugs and textiles representing the
cultures of the Mediterranean region, the Far
East, Asia, Africa, and South America.

Maine

Brunswick

Bowdoin College Museum of Art
9400 College Station 04011-8494
207.725.3275
academic.bowdoin.edu/artmuseum/
The collections of this campus museum are
arranged in several categories: ancient,
European, American, non-Western, modern,
and contemporary.

Portland

Portland Museum of Art
Seven Congress Square 04101
207.775.6148
www.portlandmuseum.org/
This regional museum specializes in works
by Maine artists, and also features works by
other American artists and European artists,
including Degas, Monet, Renoir, and
Picasso.

Rockland

Farnsworth Art Museum and Wyeth Center
16 Museum Street 04841
207.596.6457
farnsworthmuseum.org/
The Farnsworth features an extensive
collection of American art related to Maine. Its
Wyeth Center features works of Andrew Wyeth,
N.C. Wyeth, and Jamie Wyeth.

Waterville

Museum of Art
Colby College
5600 Mayflower Hill Drive 04901
207.872.3228
www.colby.edu/museum/
This campus museum's collection features
American art from the 18th, 19th, and 20th
centuries, and hosts exhibits from around the
world.

Maryland

Baltimore

American Visionary Museum
800 Key Highway 21230
410.244.1900
www.avam.org/

This regional museum features exhibits of contemporary art.

The Baltimore Museum of Art
10 Art Museum Drive 21218-3898
410.396.7100
www.artbma.org/
See description on page 45.

The Walters Art Museum
600 North Charles Street 21201
410.547.9000
www.thewalters.org/
See description on page 47.

Adelphi

Herman Maril Gallery
University of Maryland University College
3501 University Boulevard East 20783
800.888.UMUC
www.umuc.edu/maril/
This campus gallery features a collection of works by Herman Maril. Born in Baltimore, Maril is best known for his seascapes, interiors, and landscapes.

Easton

Academy Art Museum
106 South Street 21601
410.822.2787
www.art-academy.org/
This regional museum features the works of local artists.

Hagerstown

Washington County Museum of Fine Arts
Hagerstown City Park 21741
301.739.5727
http://www.washcomuseum.org/
The collection at this regional museum features 19th- and early 20th-century American Art.

Salisbury

The Ward Museum of Waterfowl Art
909 South Schumaker Drive 21804
410.742.3107
www.wardmuseum.org/
This campus museum features an extensive collection of wildfowl carving, including decoys and contemporary sculpture and painting.

Massachusetts

Amherst

Mead Art Museum
Amherst College 01002-5000
413.542.2335
www.amherst.edu/~mead/
This campus museum's collection includes art from Europe, Asia, Africa, and the Americas. It also features photographs, prints, drawings, and decorative arts.

Herter Art Gallery
University of Massachusetts Amherst
125A Herter Hall 01003
413.545.0111
www.umass.edu/art/exhibitions/herter-schedule.html
This campus gallery features exhibits of works by students and faculty, plus works of visiting artists.

Boston

Isabella Stewart Gardner Museum
280 The Fenway 02115
617.566.1401
www.gardnermuseum.org/
The collection of the Isabella Stewart Gardner Museum includes a wide variety of works from ancient Rome, Medieval Europe, Renaissance Italy, Asia, the Islamic world and 19th-century France and America, collected by Gardner for her museum. The collection is housed in a building built to resemble a 15th-century Venetian palace.

Institute of Contemporary Art
955 Boylston Street 02115
617.266.5152
www.icaboston.org
The ICA exhibits the works of many of the leading contemporary artists of the day. It was among the first American venues for Pablo Picasso, Robert Rauschenberg, and Andy Warhol.

Museum of Fine Arts
Avenue of the Arts
465 Huntington Avenue 02115-5523
617.267.9300
www.mfa.org/
See description on page 49.

PART TWO

Cambridge

Arthur M. Sackler Museum
Harvard University
485 Broadway 02138
617.495.9400
www.artmuseums.harvard.edu/
Located on Harvard's campus, the Sackler
Museum specializes in housing superb
collections of ancient, Islamic, Asian, and later
Indian art.

Busch-Reisinger Museum
Harvard University
Werner Otto Hall 02138
617.495.9400
www.artmuseums.harvard.edu/
Located on Harvard's campus, the Busch-
Reisinger Museum concentrates on the arts of
Central and Northern Europe, with a special
emphasis on the German-speaking countries.

Fogg Art Museum
Harvard University
32 Quincy Street 02138
617.495.9400
www.artmuseums.harvard.edu/
Located on Harvard's campus, the Fogg Art
Museum features Western art from the Middle
Ages to the present. Its most extensive
collections are in Italian, early Renaissance,
British pre-Raphaelite, and 19th-century French
art.

List Visual Arts Center
Massachusetts Institute of Technology
20 Ames Street
Building E5 Atrium Level 02139
617.253.4680
web.mit.edu/lvac/
Located throughout the campus, this collection
focuses on contemporary art in a wide variety of
media.

Chestnut Hill

McMullen Museum of Art
Boston College
Devlin Hall 108
140 Commonwealth 02467
www.bc.edu/bc_org/avp/cas/artmuseum/
The McMullen's collection includes art from
Europe, Asia, and the Americas. Among its
highlights are Gothic and Baroque tapestries,
Italian paintings of the 16th and 17th centuries,
and American paintings of the 19th and early
20th centuries.

Fitchburg

Fitchburg Art Museum
185 Elm Street 01420
978.345.4207
www.fitchburgartmuseum.org/
The collection in this regional museum features
American and European paintings, prints,
drawings, ceramics and decorative arts. It also
includes Greek, Roman, Asian, and pre-
Columbian antiquities.

Framingham

Danforth Museum of Art
123 Union Avenue 01702-8291
508.620.0050
www.danforthmuseum.org/
This regional museum specializes in works by
European masters and by 19th- and 20th-
century American artists.

Lincoln

DeCordova Museum and Sculpture Park
51 Sandy Pond Road 01773
781.259.8355
www.decordova.org/
Exhibits at the DeCordova specialize in works
by contemporary artists. The sculpture park
exhibits dozens of large-scale, outdoor,
contemporary American sculptures on its 35
acres.

Northampton

Smith College Museum of Art
Elm Street
Northampton, Massachusetts 01063
413.585.2760
www.smith.edu/artmuseum/
This campus museum's collection features
works by artists from around the world. It also
houses a collection of contemporary art by
women, including paintings, sculpture, and
works on paper.

Salem

Peabody Essex Museum
East India Square 01970-3783
978.745.9500
www.pem.org
The PEM's extensive collection features works
of art, architecture, and culture from around the
world.

South Hadley

Mount Holyoke College Art Museum
Lower Lake Road 01075-1499
413.538.2245
www.mtholyoke.edu/offices/artmuseum/
This campus museum's collection features a
wide range of works, including Asian art; 19th-
and 20th-century European and American
paintings and sculpture; and Egyptian, Greek,
and Roman art.

Springfield

**Dr. Seuss National Memorial Sculpture
Garden**
The Springfield Museums
220 State Street 01103
800.625.7738
www.catinthehat.org/
This regional museum specializes in art by and
about Dr. Seuss.

George Walter Vincent Smith Art Museum
The Springfield Museums
220 State Street 01103
800.625.7738
www.springfieldmuseums.org/museums/art/
Highlights of this regional museum include
exhibits of Japanese arms and armor, Chinese
cloisonné, and a plaster cast collection of
Classical and Renaissance masterpieces.

Museum of Fine Arts
The Springfield Museums
220 State Street 01103
800.625.7738
www.springfieldmuseums.org/museums/mfa/
The Springfield MFA houses works by French
Impressionists and an extensive collection of
Currier and Ives hand-colored lithographs.

Stockbridge

Norman Rockwell Museum
9 Glendale Road 01262
413.298.4100
www.nrm.org
This museum houses the world's largest and
most significant collection of original Rockwell
art.

Waltham

The Rose Art Museum
Brandeis University
415 South Street 02454

781.736.3434
www.brandeis.edu/rose/
This campus museum's collection features
American art of the 1960s and 1970s, including
works by de Kooning, Lichtenstein, and Warhol.

Wellesley

Davis Museum and Cultural Center
Wellesley College
106 Central Street 02481-8203
781.283.2051
www.davismuseum.wellesley.edu/
This campus museum's collection includes art
from Europe, Asia, Africa, and the Americas.
Among the highlights is its collection of 20th-
century prints by American artists.

Williamstown

Sterling and Francine Clark Art Institute
225 South Street 01267
413.458.2303
www.clarkart.edu/
The Clark's collection focuses on European
and American painting, sculpture, works on
paper, and decorative art from the Renaissance
to the early 20th century.

Williams College Museum of Art
15 Lawrence Hall Drive, Suite 2 01267
413.597.2429
www.wcma.org
This campus collection emphasizes modern
and contemporary art, American art from the
late 18th century to present, and the art of world
cultures.

Worcester

Worcester Art Museum
55 Salisbury Road 01609
508.799.4406
www.worcesterart.org/
This regional museum features Asian,
European, American, and ancient art.

New Hampshire

Durham

The Art Gallery
University of New Hampshire
Paul Creative Arts Center 03824
603.862.3712
www.unh.edu/art-gallery/

PART TWO

This campus gallery's collection includes paintings, drawings, prints, photography, ceramics, and sculpture. Among its collection are two hundred Japanese woodblock prints.

Hanover

Hood Museum of Art
Dartmouth College
Wheelock Street 03755
603.646.2808
www.dartmouth.edu/~hood/
This campus museum's collection includes art from Europe, Asia, Africa, Oceania, and the Americas.

Manchester

Currier Museum of Art
201 Myrtle Way 03104
603.669.6144
www.currier.org/
The Currier features European and American paintings, decorative arts, photographs, and sculpture. Among the collection are works by Picasso, Monet, O'Keeffe, and Wyeth.

New Jersey

Montclair

Montclair Art Museum
3 South Mountain Avenue 07042-1747
973.746.5555
www.montclairartmuseum.org/
This regional museum houses a collection of paintings, sculpture, and works on paper. Among the highlights is a Native American collection representing cultures across North America.

Morristown

The Morris Museum
6 Normandy Heights Road 07960
973.971.3700
www.morrismuseum.org/
The collection at this regional museum includes fine art and decorative art, featuring almost 700 musical boxes.

Newark

The Newark Museum
49 Washington Street 07102-3176
973.596.6550
www.newarkmuseum.org/

This museum's collection includes art from Europe, Asia, Africa, and the Americas. It also features a collection of ancient glass.

Oceanville

The Noyes Museum of Art
733 Lily Lake Road 08231
609.652.8848
www.noyesmuseum.org/
This museum's collection specializes in American painting and sculpture from the 19th to the 21st centuries. It also features more than 350 waterfowl decoys.

Princeton

Princeton University Art Museum
McCormick Hall 08544-1018
609.258.3788
www.princetonartmuseum.org
This campus museum collection includes ancient to contemporary art from the Mediterranean regions, Western Europe, China, the United States, and Latin America.

Trenton

New Jersey State Museum
205 West State Street 08625-0530
609.292.6464
www.state.nj.us/state/museum/
This museum's collection emphasizes New Jersey artists and includes paintings, prints, drawings, sculptures, and photographs.

New York

Albany

Albany Institute of History and Art
125 Washington Avenue 12210
518.463.4478
www.albanyinstitute.org
This regional museum concentrates on collecting items related to the Upper Hudson Valley region from the late 17th century to the present.

Buffalo

Burchfield-Penney Art Center
Buffalo State College
Rockwell Hall, Third Floor
1300 Elmwood Avenue 14222
716.878.6011
www.burchfield-penney.org

This college museum features the works of Charles E. Burchfield and several other artists of Buffalo, Niagara, and Western New York State.

Cooperstown

Fenimore Art Museum
State Route 80 13326
607.547.1400
www.fenimoreartmuseum.org
This museum houses works by the Hudson River School, collections of Native American Art and American folk art, and collection of historic photographs.

Corning

Rockwell Museum of Western Art
111 Cedar Street 14830
607.937.5386
www.stny.com/rockwellmuseum/
This regional museum features American Western and Native American art.

Elmira

Arnot Art Museum
235 Lake Street 14901
607.734.3697
www.arnotartmuseum.org
This museum features 17^{th}- to 19^{th}-century European paintings; 19^{th}- and 20^{th}- century American art; and collections of Asian, Egyptian, Pre-Columbian, and Native American art.

Glen Falls

Hyde Collection Art Museum
161 Warren Street 12801
518.792.1761
www.hydecollection.org
This collection includes paintings, sculpture, works on paper, furniture, and decorative arts.

Hamilton

Picker Art Gallery
Colgate University, Dana Arts Center
Lally Lane 13346
315.228.7634
www.pickerartgallery.org
The campus museum's collection includes paintings, drawings, prints, photographs, sculpture, and decorative arts. It features

Chinese woodcuts and an extensive photography collection.

Huntington

Heckscher Museum of Art
2 Prime Avenue 11743
631.351.3250
www.heckscher.org
This regional museum includes 19^{th}- to 21^{st}-century European and American art, and features works by regional artists.

Ithaca

Herbert F. Johnson Museum of Art
Cornell University
Central and University Avenues 14853
607.255.6464
www.museum.cornell.edu
This campus museum's collection includes art from Europe, Asia, Africa, Oceania, and the Americas.

Katonah

Katonah Museum of Art
Route 22 at Jay Street 10536
914.232.9555
www.katonahmuseum.org
Although the Katonah does not have its own permanent collection, it offers several changing exhibitions each year.

New York

Brooklyn Museum
200 Eastern Parkway 11238-6052
718.638.5000
www.brooklynmuseum.org
See description on page 51.

The Cloisters
Fort Tyron Park 10040
212.923.3700
www.metmuseum.org/works_of_art/department.asp?dep=7
A branch of the Metropolitan Museum of Art, the Cloisters specializes in the art and architecture of medieval Europe. Its highlights include illuminated manuscripts, stained glass, metalwork, enamels, ivories, and tapestries.

The Frick Collection and Frick Art Reference Library
One East Seventieth Street 10021
212.288.0700

www.frick.org/
See description on page 53.

Solomon R. Guggenheim Museum of Art
1071 Fifth Avenue 10128
212.423.3500
www.guggenheim.org
See description on page 55.

International Center of Photography
1133 Avenue of the Americas at Forty-Third
Street 10036
212.857.0000
www.icp.org
The ICP's offers changing exhibitions of
photography, and its extensive collection of
more than 100,000 photographs is open to
researchers and students by appointment only.

The Metropolitan Museum of Art
1000 Fifth Avenue 10028
212.535.7710
www.metmuseum.org
See description on page 57.

The Museum of Modern Art
11 West Fifty-Third Street 10019
212.708.9400
www.moma.org/
See description on page 59.

Museum of Arts and Design
40 West Fifty-Third Street 10019
212.956.3535
www.americancraftmuseum.org
This museum's collection features
contemporary objects created in clay, glass,
wood, metal, and fiber.

National Academy Museum
1083 Fifth Avenue 10128
212.369.4880
www.nationalacademy.org
This museum's collection features 19th- and
20th-century American art, including works from
the Hudson River School and Fauvism.

Studio Museum in Harlem
144 West 125th Street 10027
212.864.4500
www.studiomuseum.org
This museum features exhibits of contemporary
works by artists of African descent.

Whitney Museum of American Art
945 Madison Avenue 10021
800.944.8639

www.whitney.org
See description on page 61.

Ogdensburg

Frederic Remington Art Museum
303 Washington Street 13669
315.393.2425
www.fredericremington.org
This regional museum houses a collection of
original Remington paintings, sketches, and
sculptures.

Poughkeepsie

Frances Lehman Loeb Art Center
Vassar College 12604
845.437.5237
fllac.vassar.edu
This campus museum's collection includes art
from Europe, Asia, and the Americas. It
features an extensive collection of 19th-century
British and American art.

Purchase

Neuberger Museum of Art
Purchase College, State University of New York
735 Anderson Hill Road 10577
914.251.6100
www.neuberger.org
This campus museum specializes in the art of
modern, contemporary, and African art. Among
its collection are several Dada and Surrealist
objects.

Rochester

George Eastman House
900 East Avenue 14607
585.271.3361
www.eastmanhouse.org
The Eastman House's collection includes
hundreds of thousands of photographs as well
as over 25,000 films in its archives. The
museum is located on George Eastman's
estate, which includes his Colonial Revival
house and its surrounding gardens.

Memorial Art Gallery
University of Rochester
500 University Avenue 14607
585.473.7720
mag.rochester.edu
This campus museum's collection features a
wide range of art from around the world.

Southampton

Parrish Art Museum
25 Job's Lane 11968
631.283.2118
thehamptons.com/museum/
This regional museum features works by artists from the region and from around the world.

Stony Brook

Long Island Museum of American Art, History and Carriages
1200 Route 25A 11790
631.751.0066
www.longislandmuseum.org/
This museum features exhibits of works that reflect American history. Among its collection are more than 250 horse-drawn vehicles.

Syracuse

Everson Museum of Art
401 Harrison Street 13202
315.474.6064
www.everson.org
The Everson's collection features American paintings, sculpture, drawings, graphics, and ceramics.

Utica

Munson-Williams-Proctor Institute Museum of Art
310 Genesee Street 13502
315.797.0000
www.mwpai.org
This museum's collection includes 19th-century America art and decorative arts, as well as 20th-century American paintings and drawings.

Pennsylvania

Allentown

Allentown Art Museum
31 North Fifth Street 18181
610.432.4333
www.allentownartmuseum.org
This regional museum's collection includes art from Europe, Asia, and North America. It also features textiles, prints, and drawings.

Altoona

Southern Alleghenies Museum of Art at Altoona
1212 Eleventh Avenue 16603
814.946.4464
www.sama-art.org/ex_ev/altoona.htm
This campus museum features a collection of albumen photographic prints by William H. Rau.

Bethlehem

Art Galleries
Lehigh University
Zoellner Arts Center
420 East Packer Avenue 18015
610.758.3615
www.luag.org
These campus galleries exhibit works from the university's permanent collection, which includes a wide range of paintings and photography.

Kemerer Museum of Decorative Arts
459 Old York Road 18018
610.691.6055
www.historicbethlehem.org/decorative.jsp
This regional museum reflects the area's history through its collection of decorative arts, including furniture, silver, glass, textiles, china, and paintings.

Chadds Ford

Brandywine River Museum
U.S. Route 1 and PA Route 100 19317
610.388.2700
www.brandywinemuseum.org
This regional museum concentrates on art of the area, landscape and still-life paintings, and works by the Wyeths.

Doylestown

James A. Michener Art Museum
138 South Pine Street 18901
215.340.9800
www.michenerartmuseum.org/
This regional museum specializes in Pennsylvania Impressionist paintings.

PART TWO

Erie

Erie Art Museum
411 State Street 16501
814.459.5477
www.erieartmuseum.org/
This regional museum's collection includes
works in American ceramics, Tibetan paintings,
and Indian bronzes.

Greensburg

Westmoreland Museum of American Art
221 North Main Street 15601
724.837.1500
www.wmuseumaa.org/
This regional museum specializes in American
art, and it houses paintings and works by
Homer, Cassatt, and Tiffany.

Harrisburg

The State Museum of Pennsylvania
300 North Street 17120
717.787.4980
www.statemuseumpa.org/
The museum's fine art collection concentrates
on works created by Pennsylvanian artists or
works related to the state's history.

Loretto

Southern Alleghenies Museum of Art at Loretto
Saint Francis University Mall 15940
814.472.3920
www.sama-art.org/ex_ev/loretto.htm
This campus museum specializes in works of
American art.

Merion

The Barnes Foundation
300 North Latch's Lane 19066
610.667.0290
www.barnesfoundation.org/
The Barnes Foundation houses the collection of
its founder Dr. Albert C. Barnes, who amassed
an impressive collection of Modernist art as well
as many pieces of African art. The museum is
currently housed on the 12-acre arboretum
purchased by Barnes and his wife in Merion, but
may eventually move to downtown Philadelphia.
Visitors to the collection and Arboretum must
make an advance reservation.

Philadelphia

La Salle University Art Museum
1900 West Olney Avenue 19141
215.951.1221
www.lasalle.edu/museum/
This campus museum's collection features
European and American art from the
Renaissance to the present.

The Galleries at Moore College
Moore College of Art and Design
Twentieth Street and The Parkway
19103
215.965.4045
thegalleriesatmoore.org/
This pair of campus galleries exhibits works by
national and international artists, as well as by
Philadelphia-area artists.

Museum of the Pennsylvania Academy of the Fine Arts
118-128 North Broad Street 19102
215.972.7600
www.pafa.org/
The PAFA's collection of American art ranges
from colonial masters to major contemporary
artists and includes paintings, sculpture, and
works on paper.

Philadelphia Museum of Art
Benjamin Franklin Parkway and
Twenty-Sixth Street 19130
215.763.8100
www.philamuseum.org/
See description on page 63.

Arthur Ross Gallery
University of Philadelphia
Fisher Fine Arts Library
220 South Thirty-Fourth Street 19130
215.898.2083
www.upenn.edu/ARG/
This campus gallery exhibits faculty works as
well as works by national and international
artists.

Woodmere Art Museum
9201 Germantown Avenue 19118
215.247.0476
www.woodmereartmuseum.org
The Woodmere's collection concentrates on the
art and artists of the Philadelphia area, and
includes more than 600 paintings and
sculptures.

Pittsburgh

Carnegie Museum of Art
4400 Forbes Avenue 15213-4080
412.622.3131
www.cmoa.org/
The collection at the Carnegie Museum of Art features contemporary art, film, and video works. The Hall of Architecture contains one of the largest collections of plaster casts of architectural masterpieces in the world.

Elkins Park

Temple Gallery in Old City
Tyler School of Art
Temple University
45 North Second Street 19027
215.925.7379
www.temple.edu/tyler/exhibitions.html

Tyler Gallery
Tyler School of Art
Temple University
7725 Penrose Avenue 19027
215.782.2828
www.temple.edu/tyler/exhibitions.html
This campus gallery features works by regional, national, and international artists.

Reading

Reading Public Museum
500 Museum Road 19611
610.371.5850
www.readingpublicmuseum.org/
This regional museum offers an extensive collection of art from around the world. It also features an arboretum and planetarium.

University Park

Palmer Museum of Art
College of Arts and Architecture
Pennsylvania State University
Curtin Road 16802
814.865.7672
www.psu.edu/dept/palmermuseum/
This campus museum offers an outdoor sculpture garden and 11 galleries, which feature exhibits drawn from its collection of American and European paintings, drawings, photographs, prints, and sculptures; Asian ceramics, jades, paintings, and prints; and objects from ancient European, African, and Near Eastern cultures.

Rhode Island

Kingston

Fine Arts Center Galleries
University of Rhode Island
105 Upper College Road 02881-0820
401.874.2775
www.uri.edu/artgalleries/
These campus galleries present exhibits of contemporary art.

Newport

Newport Art Museum
76 Bellevue Avenue 02840
401.848.8200
www.newportartmuseum.com/
This regional museum presents exhibits of works by regional, national, and international artists.

Providence

Edward Mitchell Bannister Gallery
Rhode Island College
Roberts Hall, 124
600 Mount Pleasant Avenue 02908
401.456.9765
www.ric.edu/bannister/
This campus gallery presents exhibits of works in traditional media, as well as in contemporary site specific, electronic, and video projects.

David Winton Bell Gallery
List Art Center
Brown University
64 College Street 02912
401.863.2932
www.brown.edu/Facilities/David_Winton_Bell_Gallery/
This campus gallery features collections of Old master prints; 19th-century prints; as well as modern and contemporary prints, photography drawings, photography, paintings, and sculpture.

Museum of Art
Rhode Island School of Design
224 Benefit Street 02903
401.454.6500
www.risd.edu/museum.cfm
The RISD Museum houses over 80,000 works of art, ranging from ancient Greek and Roman sculpture to Chinese terracotta sculpture to French Impressionist paintings. It also includes

contemporary textiles, ceramics, glass, and furniture.

Vermont

Bennington

Bennington Museum
Route 9 05201
802.447.1571
www.benningtonmuseum.com
This regional features the largest public collection of Grandma Moses's paintings. It also displays collections of Bennington pottery and American glass.

Burlington

Robert Hull Fleming Museum
University of Vermont
61 Colchester Avenue 05405
802.656.2090
www.flemingmuseum.org
This campus museum features a collection of more than 20,000 objects, including works from the cultures from early Mesopotamia through contemporary America. The galleries display art and artifacts from Ancient Egypt, Africa, India, Europe, and the Americas.

Middlebury

Middlebury College Museum of Art
Center for the Arts 05753
802.443.5007
www.middlebury.edu/~museum/
This campus museum's collection includes objects from antiquities through contemporary art, and emphasizes photography, 19^{th}-century European and American sculpture, and contemporary prints.

Montpelier

T. W. Wood Gallery and Arts Center
Vermont College
College Hall 05602
802.223.8743
www.vmga.org/washington/wood.html
This campus gallery was founded by Thomas Waterman Wood, president of the National Academy of Design from 1891 to 1899. The collections include 550 paintings by Wood and his contemporaries, including Asher Durand, J. G. Brown, William Beard, and Frederick Church.

Virginia

Abingdon

William King Regional Arts Center
415 Academy Drive 24212-2256
276.628.5005
www.wkrac.org/
At this public venue, exhibits feature regional art and decorative arts, as well as art from around the world.

Alexandria

The Northern Virginia Fine Arts Association at the Athenaeum
201 Prince Street 22314
703.548.0035
www.nvfaa.org
A private, regional facility, the NVFAA presents exhibits on painting and other fine arts, including architecture, weaving, film, and photography.

Torpedo Factory Art Center
105 North Union Street 22314-3217
703.838.4565
Located on the docks of the Potomac River in a renovated World War I torpedo factory, this private enterprise is one of the nation's largest visual arts centers, featuring five galleries and more than eighty working studios.

Charlottesville

Art Museum
University of Virginia
Thomas H. Bayly Building
155 Rugby Road 22904-4119
434.924.3592
www.virginia.edu/artmuseum/
The UVAM exhibits American and European painting and sculpture of the 15^{th} through 19^{th} centuries, including art from the "Age of Thomas Jefferson" (1775–1825); art from the ancient Mediterranean; Asian art; and 20^{th}-century art. Highlights include the collection of 20^{th}-century paintings, sculpture, and works on paper, including American figurative art and photography.

Kluge-Ruhe Aboriginal Art Collection of the University of Virginia
400 Worrell Drive
Peter Jefferson Place 22911
434.244.0234

www.virginia.edu/kluge-ruhe/
This museum holds one of the finest private collections of Australian Aboriginal art in the world, featuring a collection of 1600 paintings on canvas and eucalyptus bark made by Aboriginal Australian artists.

Fredericksburg

Belmont, The Gari Melchers Estate and Memorial Gallery
224 Washington Street 22405
540.654.1015
www.umw.edu/belmont/index.html
Associated with and located near the University of Mary Washington, Belmont includes the home, studio, and gardens of Gari Melchers, one of the most decorated American artists of the early 20th century. The studio and its galleries house the largest collection—approximately 1600 items—of Melchers' paintings and drawings.

University of Mary Washington Galleries
University of Mary Washington
1301 College Avenue 22401
540.654.1013
www.umw.edu/umw_galleries/
Two galleries are located on this university campus. The Ridderhof Martin Gallery hosts exhibitions brought in from museums around the country, or drawn from the school's permanent collection of over 5,000 works. The permanent collection is strongest in 20th-century art and Asian art. The Dupont Gallery features painting, drawing, sculpture, photography, ceramics, and textiles by art faculty, students and other contemporary artists.

Hampton

Hampton University Museum
Hampton University
Huntington Building 23668
757.727.5308
Located on the campus of this historically African American university, this is the oldest African American museum in the United States and one of the oldest museums in the state of Virginia. The collections feature over 9,000 objects, including African American fine arts, traditional African, Native American, Native Hawaiian, Pacific Island, and Asian art. The museum holds one of the nation's largest and most comprehensive collections

of materials on the history and culture of African Americans and Native Americans.

Harrisonburg

Madison Art Collection
James Madison University
College Center 22807
540.568.6934
web.jmu.edu/mars
Objects in this collection range from the late Neolithic Period to contemporary art. Strengths include the ancient Near East, ancient Egypt, ancient Greece and Rome, West Africa, and Russian religious art. The collection is also an official repository of arts and crafts objects created in the 1930s under the Works Progress Administration (WPA), including quilts, prints, and paintings.

Sawhill Gallery
James Madison University
Duke Hall
Main and Grace Streets 22807
540.568.6211
www.jmu.edu/art/index.html
This professional gallery features changing exhibitions of international, national, and regional significance.

Lexington

Dupont Gallery
Washington and Lee University
Dupont Hall 24450
540.458.8859
www2.wlu.edu/
This gallery displays works selected from the school's extensive collections that include landscape paintings; western art; 19th-century American paintings; and Chinese, Japanese, and Korean ceramics, bronzes, and jades.

Lynchburg

The Daura Gallery
Lynchburg College
Dillard Fine Arts Center
1501 Lakeside Drive 24501
434.544.8343
www.lynchburg.edu/x619.xml
This gallery's collection includes paintings, drawings, prints, and sculpture by Pierre Daura and many other American and European artists.

Maier Museum of Art
Randolph-Macon Woman's College
2500 Rivermont Avenue 24503
434.947.8136
maiermuseum.rmwc.edu/
This museum houses a collection of American art, chiefly paintings, works on paper, and photographs dating from the 19th and 20th centuries.

Newport News

Peninsula Fine Arts Center
101 Museum Drive 23606
757.596.8175
www.pfac-va.org/
This multi-disciplinary arts center exhibits the works of regional artists and period works on loan from other institutions.

Norfolk

Chrysler Museum of Art
245 West Olney Road 23510
757.664.6200
www.chrysler.org/
See description on page 65.

The Hermitage Foundation Museum
7637 North Shore Road 23505
757.423.2052
www.hermitagefoundation.org
The Hermitage Foundation Museum includes Native American woven baskets, Indian Chola bronze statues, Spanish religious icons and furniture, European ceramics and paintings, American Impressionist paintings and sculptures, hand-painted glass windows from Germany, ivory carvings, Persian rugs, and ritual bronzes and ceramic tomb figures from China.

Portsmouth

Portsmouth Museums
High and Court Streets 23704
757.393.8543
www.courthousegalleries.com/
Housed in the 1846 Courthouse, this museum exhibits Eastern, Western, multicultural, traditional, and contemporary art forms.

Richmond

Anderson Gallery
Virginia Commonwealth for the Arts
907½ West Franklin Street 23284
804.828.1522
www.pubinfo.vcu.edu/artweb/gallery/surface
Charge/surface/index.asp
In addition to presenting exhibitions, publications, and lecture series, the Anderson Gallery is known for its extensive permanent collection, which includes works by such artists as Dürer, Rembrandt, Renoir, Toulouse-Lautrec, and Warhol.

University of Richmond Museums
University of Richmond
28 Westhampton Way 23173
804.289.8276
museums.richmond.edu
Known collectively as the University Museums, these museums consist of three major collections: the Joel and Lila Harnett Museum of Art, the Joel and Lila Harnett Museum of Art and the Print Study Center, and the Lora Robins Gallery of Design from Nature.

Virginia Museum of Fine Arts
200 North Boulevard 23220-4007
804.340.1400
www.vmfa.state.va.us/
The VMFA features a wide variety of exhibits, including 19th- and 20th-century painting and sculpture in France, 19th- and 20th-century decorative arts, modern and contemporary art, Dutch and Flemish art, and works from African and Asian cultures.

Roanoke

Art Museum of Western Virginia
Center in the Square
One Market Square 24011-1436
540.342.5760
www.artmuseumroanoke.org/
The Art Museum features 19th- and 20th-century American art, contemporary and modern art, decorative arts, and works on paper, and presents exhibitions of both regional and national significance.

Sweet Briar

Sweet Briar College Art Gallery
Anne Gary Pannell Center
Sweet Briar, Virginia 24595
434.381.6100
www.artgallery.sbc.edu/
This gallery's collection includes
approximately one thousand paintings, works
on paper, sculpture, and decorative arts.
Special exhibits include European works on
paper from the 13th through the 19th
centuries, 20th-century American paintings,
and Japanese woodblock prints.

Williamsburg

Muscarelle Museum of Art
College of William and Mary
Jamestown Road 23187-8795
757.221.2710
www.wm.edu/muscarelle/
This museum houses a permanent collection
of over 3,500 art objects and hosts national
traveling exhibitions.

West Virginia

Charleston

Juliet Art Museum
Clay Center for the Arts and Sciences
One Clay Square
300 Leon Sullivan Way 25301
304.561.3575
www.avampatodiscoverymuseum.org/art/index.
php
This municipal museum's collection consists of
more than 750 pieces, primarily works on paper
by American artists from the 19th and 20th
centuries.

West Virginia State Museum
1900 Kanawha Blvd East 25305-0009
304.558.0220
www.wvculture.org/museum/museumindex.aspx
Located in the state capitol, this museum houses
collections and exhibits of West Virginia history
and artwork.

Huntington

Birke Art Gallery
Marshall University
Smith Hall 1st Floor
Third Avenue 25755
304.696.2296
www.marshall.edu/cofa/art/site.asp?pname=gal
leries
This gallery displays art by students, faculty,
and visiting artists.

Huntington Museum of Art
2033 McCoy Road 25701
304.529.2701
www.hmoa.org/
This municipal museum's collection includes
paintings, prints, sculpture, glass, and silver.

Morgantown

The Mesaros Galleries
West Virginia University
College of Creative Arts
Evansdale Drive 26506
304.293.4841
These two campus galleries display art by
students, faculty, visiting artists, as well as art
from the university's permanent collection.

Weston

West Virginia Museum of American Glass
Main Avenue and Second Street 26452
304.269.5006
members.aol.com/wvmuseumofglass/
Exhibits at this municipal museum are intended
to share the diverse and rich heritage of glass
as a product and historical object, and to
provide a record of the lives and contributions
of glass workers and the tools and machines
they used in glass houses.

Wheeling

Oglebay Institute
1330 National Road
Wheeling, WV 26003
304.242.7700
www.oionline.com/home.htm
The state's largest private arts organization
includes the Glass Museum, which displays cut
lead crystal, Victorian art glass, Peachblow,
depression, and Northwood's carnival glass;
and the Stifel Fine Arts Center, which features
a wide range of art exhibits.

APPENDIX

A Selection of Museums in the United States

Alabama

Auburn

Jule Collins Smith Museum of
Fine Art
Auburn University
901 South College Street 36830
334.844.3081
www.julecollinssmithmuseum.
com/index.html

Birmingham

Birmingham Museum of Art
2000 Eighth Avenue North 35203-2278
205.254.2566
www.artsbma.org

Visual Arts Gallery
University of Alabama at Birmingham
Arts and Humanities Building
900 South Thirteenth Street 35294-1260
205.934.0815
www.main.uab.edu

Dothan

Wiregrass Museum of Art
126 Museum Avenue 36302
334.794.3871
www.wiregrassmuseumoart.org/

Gadsden

Gadsden Museum of Art
2829 W. Meighan Boulevard 35904
256.535.4350
www.watchgadsden.com/museum.htm

Huntsville

Huntsville Museum of Art
300 Church Street, South 35801
256.535.4350 800.786.9095
www.hsvmuseum.org/

University Center Gallery
University of Alabama at Huntsville
301 Sparkman Drive 35899
256.824.1000
www.uah.edu/colleges/liberal/art/gallery/ga
llery.html

Mobile

Mobile Museum of Art
4850 Museum Drive 36608
251.208.5200
www.mobilemuseumofart.com/

Montgomery

Montgomery Museum of Fine Arts
Wynton M. Blount Cultural Park
One Museum Drive 36117
334.244.4333
www.mmfa.org/

Tuscaloosa

Sarah Moody Gallery of Art
University of Alabama
Garland Hall 35487-0270
205.348.5967
bama.ua.edu/~artweb/moody.html

Alaska

Anchorage

Anchorage Museum of History and Art
121 West Seventh Avenue 99501
907.343.6173
www.anchorgemuseum.org/

Fairbanks

University of Alaska Museum of the North
907 Yukon Drive 99775-6960
907.474.7505
www.uaf.edu/museum/

Haines

Sheldon Museum and Cultural Center
First Avenue and Front Street 99827
907.766.2366
sheldonmuseum.org/

Homer

Pratt Museum
3779 Bartlett Street 99603-7597
907.235.8635
www.prattmuseum.org/

Kodiak

Kodiak Historical Society and Baranov
Museum
101 Marine Way 99615
907.486.5920
www.baranov.us/

Unalaska

Museum of the Aleutians
314 Salmon Way 99685
907.581.5150
www.aleutians.org/

Arizona

Flagstaff

Museum of Northern Arizona
3101 North Fort Valley Road 86001
928.774.5213
www.musnaz.org/

Kingman

Mojave Museum of History and Arts
400 West Beale Street 86401
928.753.3195
www.ctaz.com/~mocohist/museum/

Phoenix

Heard Museum
2301 North Central Avenue 85004-1323
602.252.8848
www.heard.org/

Phoenix Art Museum
1625 North Central Avenue 85004-1685
602.257.1222
www.phxart.org/

Scottsdale

Scottsdale Museum of Contemporary Art
7374 East Second Street 85251
480.994.2787
www.smoca.org/

Tempe

Arizona State University Art Museum
Nelson Fine Arts Center 85287
480.965.2787
asuartmuseum.asu.edu/

Tucson

Arizona State Museum
The University of Arizona
1013 East University Boulevard 85721
520.621.6302
www.statemuseum.arizona.edu/

De Grazia Gallery in the Sun
6300 North Swan 85718
800.545.2185 520.299.9191
www.degrazia.org/

Tucson Museum of Art
140 North Main Avenue 85701
520.624.2333
www.tucsonarts.com/

University of Arizona Museum of Art
Park Avenue and Speedway Boulevard
85721
520.621.7567
artmuseum.arizona.edu/

Arkansas

Conway

Baum Gallery of Fine Art
University of Central Arkansas
McCastlain Hall 72035
501.450-5793
www.uca.edu/cfac/baum/

Fayetteville

Fine Arts Gallery
University of Arkansas
116 Fine Arts Center 72701
479.575.5202
www.uark.edu/~artinfo/gallery.html

Little Rock

Arkansas Arts Center
501 East Ninth Street 72202
501.372.4000
www.arkarts.com/

University Galleries
University of Arkansas at Little Rock
Department of Art
2801 South University 72204
501.569.3182
www.ualr.edu/artdept/gallery/index.html

APPENDIX

Pine Bluff

 Arts and Science Center for Southeast
Arkansas
701 South Main Street 71601
870.536.3375
www.artssciencecenter.org/

 Leedell Moorehead-Graham Fine Arts Gallery
University of Arkansas at Pine Bluff
Isaac Hathaway Fine Arts Center
1200 North University Drive 71601
870.543.8236
www.uapb.edu/

California

Bakersfield

 Bakersfield Museum of Art
1930 R Street 93303
661.323.7219
www.bmoa.org/

Berkeley

 Berkeley Art Museum and Pacific Film
Archive
University of California, Berkeley
2625 Durant Avenue #2250 94720-2250
510.642.0808
www.bampfa.berkeley.edu/

Fresno

 Fresno Art Museum
2233 North First Street 93703
559.441.4221
www.fresnoartmuseum.org/

 Fresno Metropolitan Museum
1515 Van Ness Avenue 93721-1200
559.441.1444
www.fresnomet.org/

Los Angeles

 California African American Museum
600 State Drive 90037
213.744.7432
www.caamuseum.org/

 Fisher Gallery
University of Southern California
823 Exposition Boulevard 90089-0292
213.740.4561
www.usc.edu/org/fishergallery

 Fowler Museum of Cultural History
University of California, Los Angeles
North Campus 90095
310.825.4361
www.fmch.ucla.edu/

 Hammer Museum
University of California, Los Angeles
10899 Wilshire Boulevard 90024
310.443.7000
www.hammer.ucla.edu/

 J. Paul Getty Museum
The Getty Center
1200 Getty Center Drive 90049-1687
310.440.7300
www.getty.edu/museum/

 Los Angeles County Museum of Art
5905 Wilshire Boulevard 90036
323.857.6000
www.lacma.org/

 Museum of Contemporary Art at
California Plaza
2050 South Grand Avenue 90012
213.626.6622
www.moca-la.org/

Long Beach

 Long Beach Museum of Art
2300 East Ocean Boulevard 90803
562.439.2119
www.lbma.org/

 University Art Museum
California State University, Long Beach
1250 Bellflower Boulevard 90840
562.985.5761
www.csulb.edu/org/uam/

Malibu

 Frederick R. Weisman Museum of Art
24255 Pacific Coast Highway 90263
310.506.4000
www.pepperdine.edu/cfa/weismanmuse
um.htm

 The Getty Villa Malibu
17985 Pacific Coast Highway
Pacific Palisades
310.440.7300
www.getty.edu/museum/

Monterey

Monterey Museum of Art
559 Pacific Street 93940
831.372.5477
www.montereyart.org/

Morago

Hearst Art Gallery
Saint Mary's College
1928 Saint Mary's Road 94575
925.631.4379
www.stmarys-ca.edu/arts/art_gallery/

Pasadena

The American Museum of Beat Art
30 North Raymond Avenue 91103
626.683.3926
www.beatmuseum.org/

Norton Simon Museum
411 West Colorado Boulevard
626.449.6840
www.nortonsimon.org/

Riverside

Sweeney Art Gallery
University of California, Riverside
909.787.3755
sweeney.ucr.edu/

Sacramento

Crocker Art Museum
216 O Street 95814
916.264.5423
www.crockerartmuseum.org/

Santa Ana

The Bowers Museum of Cultural Art
2002 North Main Street 92706
714.567.3600
www.bowers.org/

Santa Barbara

Santa Barbara Museum of Art
1130 State Street 93101
805.963.4364
www.sbmuseart.org/

University Art Museum
University of California, Santa Barbara
Santa Barbara 93106-7130
805.893.2951
www.uam.ucsb.edu/

Santa Clara

de Saisset Museum
Santa Clara University
500 El Camino Real 95053-0550
408.554.4528
www.scu.edu/deSaisset/

Santa Cruz

The Museum of Art and History
705 Front Street 95060
831.429.1964
www.santacruzmah.org/

San Diego

San Diego Museum of Contemporary
Art
1001 Kettner Boulevard 92101
700 Prospect Street, La Jolla 92037
619.234.1001 858.454.6985
www.mcasd.org/

Mingei International Museum
1439 El Prado, Balboa Park 92101
619.239.0003
www.mingei.org/

Museum of Photographic Arts
1649 El Prado, Balboa Park 92101
619.238.7559
www.mopa.org/

San Diego Museum of Art
1450 El Prado, Balboa Park 92112-2107
619.232.7931
www.sdmart.org/

Timken Museum of Art
1500 El Prado, Balboa Park 92101
619.239.5548
www.timkenmuseum.org/

San Francisco

The Asian Art Museum
200 Larkin Street 94102
415.581.3500
www.asianart.org/

de Young Museum
50 Hagiwara Tea Garden Drive 94118
415.863.3330
www.thinker.org/deyoung/

Palace of the Legion of Honor
Thirty-Fourth Avenue and
Clement Street 94121
415.863.3330
www.legionofhonor.org

San Francisco Museum of Modern Art
151 Third Street 94103-3159
415.357.4000
www.sfmoma.org/

San Jose

San Jose Museum of Art
110 South Market Street 95113
408.271.6840
www.sjmusart.org/

San Marino

Huntington Library, Art Collections, and
Botanical Gardens
1151 Oxford Road 91108
626.405.2100
www.huntington.org/

Stanford

Iris and B. Gerald Cantor Center for
Visual Arts
328 Lomita Drive and Museum Way 94305
650.723.4177
www.stanford.edu/dept/ccva/

Stockton

The Haggin Museum
1201 North Pershing Avenue 95203-1699
209.940.6300
www.hagginmuseum.org/

Colorado

Aspen

Aspen Art Museum
590 North Mill Street 81611
970.925.8050
www.aspenartmuseum.org/

Boulder

CU Art Museum
University of Colorado at Boulder
Sibell-Wolle Fine Art Building 80309
303.492.8300
www.colorado.edu/cuartmuseum/

Boulder Museum of Contemporary Art
1750 Thirteenth Street 80306
303.443.2122
www.bmoca.org/

Colorado Springs

Gallery of Contemporary Art
University of Colorado
1420 Austin Bluffs Parkway 80918
719.262.3567
galleryuccs.org/

Fine Arts Center
30 West Dale Street 80903
719.634.5581
www.csfineartscenter.org/

Denver

The Denver Art Museum
100 West Fourteenth Avenue Parkway
80204
720.865.5000
www.denverartmuseum.org/

Museum of Contemporary Art
1275 Nineteenth Street 80202
303.298.7554
www.mcartdenver.org/

Englewood

Museum of Outdoor Arts
1000 Englewood Parkway 80110
303.806.0444
www.moaonline.org/

Loveland
Loveland Museum and Gallery
503 North Lincoln Avenue 80537
970.962.2410
www.ci.loveland.co.us/museum/museum.htm

Connecticut

See listings starting on page 67.

Delaware

See listings starting on page 68.

District of Columbia

See listings starting on page 69.

Florida

Avon Park

Museum of Florida Art and Culture
South Florida Community College
600 West College Drive 33825
863.784.7240
www.mofac.org

Boca Raton

Boca Raton Museum of Art
Mizner Park 501 Plaza Real 33432
561.391.6410
www.bocamuseum.org/

University Galleries
Florida Atlantic University
777 Glades Road 33431-0991
561.297.2966
www.fau.edu/galleries

Coral Gables

The Florida Museum of Hispanic and Latin
American Art
2206 Southwest Eighth Street 33135
305.644.1127
www.latinartmuseum.org/

Lowe Museum
University of Miami
1301 Stanford Drive 33124-6310
305.284.3535
www.lowemuseum.org

Coral Springs

Coral Springs Museum of Art
2855 Coral Springs Drive 33065
954.340.5000
www.csmart.org/

Daytona Beach

Museum of Arts and Sciences and Center
for Florida History
352 South Nova Road 32114

904.255.0285
www.moas.org

Southeast Museum of Photography
Daytona Beach Community College
1200 International Speedway Boulevard
386.506.4475
www.smponline.org

Deland

African American Museum of Art
325 South Clara Avenue 32721
386.736.4004
www.africanmuseumdeland.org/

Deland Museum of Art
600 North Woodland Boulevard 32720
386.734.4371
www.delandmuseum.com

Duncan Art Gallery
Stetson University
421 North Woodland Boulevard 32723
904.822.7266

Delray Beach

Cornell Museum of Art and History
51 North Swinton Avenue 33444
561.243.7922
www.oldschool.org/cornell.html

Morikami Museum and Japanese Gardens
4000 Morikami Park Road 33446
561.495.0233
www.morikami.org

Fort Lauderdale

Fort Lauderdale Museum of Art
One East Las Olas Boulevard 33301
954.525.5500
www.moafl.org/

Fort Myers

Bob Rauschenberg Gallery
Edison Community College
Lee County Campus, Humanities Building
8099 College Parkway SW 33906-6210
239.489.9313
www.edison.edu/

APPENDIX

Fort Walton Beach

Fort Walton Beach Art Museum
38 Robinwood Drive Southwest 32549
850.244.1893

Gainesville

Samuel P. Harn Museum of Art
University of Florida
Southwest Thirty-Fourth Street and Hull
Road 32611-2700
352.392.9826
www.harn.ufl.edu/

University Galleries
University of Florida
Fine Arts Campus Complex 32611
352.392.0201
www.arts.ufl.edu/galleries

Jacksonville

Alexander Brest Gallery and Museum
Jacksonville University
Phillips Fine Arts Building
2800 University Boulevard North 32211
904.256.7371
www.ju.edu/

Cummer Museum of Art and Gardens
829 Riverside Avenue 32204
904.356.6857
www.cummer.org

Jacksonville Museum of Modern Art
333 North Laura Street 32202
904.366.6911
www.jmoma.org

Jupiter

The Hibel Museum of Art
Florida Atlantic University
John D. MacArthur Campus
5353 Parkside Drive 33458
561.622.5560
www.hibelmuseum.org/

Key West

East Martello Gallery and Museum
3501 South Roosevelt Boulevard 33040
305.296.3913
www.kwahs.com

Key West Museum of Art and History
Custom House
281 Front Street 33040
305.295.6616
www.kwahs.com

Lake Worth

Art Gallery at PBCC
Palm Beach Community College
Edward M. Eissey Campus
Arts and Humanities Building, BB 113
4200 Congress Avenue 33461
561.207.5015
www.pbcc.edu/artgallery/index.asp

Lakeland

Polk Museum of Art
800 East Palmetto Street 33801
863.688.7743
www.polkmuseumofart.org/content/

Largo

Gulf Coast Museum of Art
12211 Walsingham Road 33778
727.518.6833
www.gulfcoastmuseum.org

Longboat Key

Longboat Key Center for the Arts
6860 Longboat Drive South 34228
941.383.2345
www.lbkca.org

Melbourne

Brevard Museum of Art and Science
1463 Highland Avenue 32936-0835
321.242.0737
www.artandscience.org/

Miami

Art Gallery
Miami-Dade College, Kendall Campus
11011 Southwest 104th Street 33176-3393
305.237.2322
www.mdc.edu/kendall/art/

Frost Art Museum
Florida International University
11200 Southwest Eighth Street 33199
305.348.2890
www.frostartmuseum.org

Gallery North, Miami Dade College
North Campus Leroy Collins Student Center
Room 4207-1
11380 NW Twenty-Seventh Avenue 33167
305.237.1532

Martin Z. Margulies Sculpture Park
Florida International University
Southwest 107th Avenue and Southwest
Sixteenth Street 33199
305.348.2897
www.marguliessculpturepark.org/

Miami Art Central
5960 SW 57th Avenue 33143
305.455.3333
www.miamiartcentral.org

Miami Art Museum
101 West Flagler Street 33130
305.375.3000
www.miamiartmuseum.org

Museum of the Americas
2500 Northwest 79th Avenue 33122
305.599.8089
www.museumamericas.org

Vizcaya Museum and Gardens
3251 South Miami Avenue 33129
305.250.9133
www.vizcayamuseum.org/

Wolfson Campus Galleries
Miami Dade College, Wolfson Campus
Northeast Second Avenue 33132
305.237.3696
www.mdc.edu/wolfson/Academic/ArtsLette
rs/art_philosophy/

Miami Beach

Bass Museum of Art
2121 Park Avenue 33139
305.673.7530
www.bassmuseum.org/

The Wolfsonian
Florida International University
1001 Washington Avenue 33139
305.531.1001
www.wolfsonian.fiu.edu/

Mount Dora

Mount Dora Center for the Arts
138 East Fifth Avenue 32757

352.383.0880
www.mountdoracenterforthearts.org

Naples

Naples Museum of Art
5833 Pelican Bay Boulevard 33963
239.597.1111
www.thephil.org

Von Liebig Art Center
585 Park Street 34102
239.262.6517
www.naplesart.org

Niceville

Arts Center Galleries
Okaloosa-Walton College
100 College Boulevard 32578
850.729.6044
www.owc.edu/arts/

North Miami

Museum of Contemporary Art
Joan Lehman Building
770 Northeast 125th Street 33161
305.893.6211
www.mocanomi.org/

Ocala

Appleton Museum of Art
Central Florida Community College
4333 Northeast Silver Springs Boulevard
34470-5000
352.291.4455
www.appletonmuseum.org

Orlando

Anita S. Wooten Gallery
Valencia Community College
East Campus
701 North Econlockhatchee Trail 32825
407.582.2298
www.valenciacc.edu/gallery/

The Art Gallery
University of Central Florida
Visual Arts Building 32816
407.823.3161
www.art.ucf.edu

APPENDIX

Menello Museum of American Art
900 East Princeton Street 32803
407.246.4278
www.mennellomuseum.com

Orlando Museum of Art
2416 North Mills Avenue 32803-1493
407.896.4231
www.omart.org/

Ormond Beach

Ormond Memorial Art Museum and
Gardens
78 East Granada Boulevard 32176
386.676.3347
www.ormondartmuseum.org/

Panama City

Gulf Coast Community College Art Gallery
5230 West Highway 98 32401
850.873.3520

Visual Arts Center of Northwest Florida
19 East Fourth Street 32401
850.769.4451
www.vac.org.cn

Pembroke Pines

The Art Gallery
Broward Community College
South Campus, Building 69
7200 Pines Boulevard 33024
954.201.8895
www.broward.edu/locations/south/artgaller
y/index.jsp

Pensacola

Anna Lamar Switzer Center for Visual Arts
Pensacola Junior College
Pensacola Campus Visual Arts Building
1000 College Boulevard 32504
850.484.2550
www.pjc.edu/visarts

Art Gallery
University of West Florida
Center for Fine and Performing Arts
11000 University Parkway 32526
850.474.2541
uwf.edu/artgallery/uwfgallery/

Pensacola Museum of Art
University of West Florida

407 South Jefferson Street 32502
850.432.6247
www.pensacolamuseumofart.org/

St. Augustine

Lightner Museum
75 King Street 32084
904.824.2874
www.lightnermuseum.org

St. Petersburg

Elliot Gallery
Eckerd College
Ransom Art Center
4200 Fifty-Fourth Avenue South 33711
727.864.8340

Salvador Dalí Museum
1000 Third Street South 33701-4901
727.823.3767 800-442-3254
www.salvadordalimuseum.org/

Museum of Fine Arts
255 Beach Drive, Northeast 33701
727.896.2667
www.fine-arts.org

Sarasota

Art Center Sarasota
707 North Tamiami Trail 34236
941.365.2032
www.artsarasota.org

The John and Mable Ringling Museum of Art
5401 Bay Shore Road 34243
941.359.5762
www.ringling.org/

Sebring

Highlands Museum of the Arts
351 West Center Avenue33870
863.385.5312
www.highlandsartleague.com

Tallahassee

Foster-Tanner Fine Arts Gallery
Florida A&M University
Foster-Tanner Building 32307
850.599.3161
www.famu.edu

Mary Brogan Museum of Art and Science
350 South Duval 32301
850.513.0700
www.thebrogan.org

Museum of Fine Arts
Florida State University
250 Fine Arts Building
Corner of West Tennessee and Copeland
Streets 32306-1140
850.644.6836
www.mofa.fsu.edu/

Tampa

Contemporary Art Museum
University of South Florida
4202 East Fowler Avenue 33620
813.974.4133
www.usfcam.usf.edu/

Tampa Museum of Art
600 North Ashley Drive 33602
813.274.8130
www.tampamuseum.com

Scarfone/Harley Gallery
University of Tampa
R. K. Bailey Arts Studios
310 North Boulevard 33606
813.253.3333
www.ut.edu/academics/liberalarts/departm
ents/art/galleries.html

Tarpon Springs

Leepa-Rattner Museum of Art
St. Petersburg Community College
Tarpon Springs Campus
600 Klosterman Road 34688
727.712.5762
www.spcollege.edu/central/museum/index.htm

Venice

Venice Art Center
390 Nokomis Avenue South 34285
941.485.7136
www.veniceartcenter.com/

Vero

Vero Beach Museum of Art
3001 Riverside Park Drive 32963
772.231.0707
www.vbmuseum.org

West Palm Beach

Ann Norton Sculpture Garden
253 Barcelona Road 33401
561.835.5328
www.ansg.org

Norton Museum of Art
1451 South Olive Avenue 33401
561.832.5196
www.norton.org/

Winter Haven

Polk Community College Art Gallery
999 Avenue H, Northeast 33881
863.297.1050
www.polk.edu

Winter Park

Albin Polasek Museum and Sculpture
Garden
633 Osceola Avenue 32789
407.647.6294
www.polasek.org

The Charles Hosmer Morse Museum of
American Art
445 North Park Avenue 32789
407.645.5311
www.morsemuseum.org/

Cornell Fine Arts Museum
Rollins College
1000 Holt Avenue 32789
407.646.2526
www.rollins.edu/cfam/

Crealdé School of Art
600 Saint Andrews Boulevard 32792
407.671.1886
www.crealde.org

Georgia

Albany

Albany Museum of Art
311 Meadowlark Drive 31707
229.439.8400
www.albanymuseum.com

Athens

Georgia Museum of Art
University of Georgia

93

90 Carlton Street 30602-6719
706.542.4662
www.uga.edu/gamuseum/home.html

Lyndon House Arts Center
293 Hoyt Street 30601
706.613.3623

Atlanta

Clark Atlanta University Art Gallery
Park Street Art and Music Complex
793 Park Street, SW 30310
404.880.8122
www.cau.edu/

Hammonds House Galleries and Resource
Center for African American Art
503 Peeples Street, Southwest 30310
404.752.8730
www.hammondshouse.org

The High Museum of Art
1280 Peachtree Street, Northeast 30309
404.733.4400
www.high.org

Michael C. Carlos Museum
Emory University
571 South Kilgo Circle 30322
404.727.4282
carlos.emory.edu/

Museum of Contemporary Art of Georgia
1447 Peachtree Street 30309
404.881.1109
www.mocaga.org/root.asp

Oglethorpe University Museum of Art
4484 Peachtree Road, Northeast 30319
404.364-8555
museum.oglethorpe.edu/

SCAD-Atlanta
1600 Peachtree Street, Northeast 30309
404.733.5050
www.aca.edu/home.htm

Augusta

Gertrude Herbert Institute of Art
506 Telfair Street 30901
706.722.5495
www.ghia.org

Morris Museum of Art
One Tenth Street 30901
706.724.7501
www.themorris.org/

Cartersville

Booth Western Art Museum
501 Museum Drive 30120
770.387.1300
www.boothmuseum.org

Columbus

The Columbus Museum
1251 Wynnton Road 31906
706.748.2562
www.columbusmuseum.com/

Duluth

Jacqueline Casey Hudgens Center for the Arts
Building 300
6400 Sugarloaf Parkway 30097
770.623.6002
www.artsgwinnett.org/

Gainesville

Galleries
Brenau University
One Centennial Circle 30501
770.534.6263
artsweb.brenau.edu/Galleries/

Kennesaw

The Art Galleries
Kennesaw State University
1000 Chastain Road 30144
770.499.3223
www.kennesaw.edu/visual_arts/art_galleri
es.shtml

Macon

Museum of Arts and Sciences
4182 Forsyth Road 31210
478.477.3232
www.masmacon.com

Tubman African American Museum
340 Walnut Street 31201
478.743.8544
www.tubmanmuseum.com/

Madison

Madison Museum of Fine Art
290 Hancock Street 30650
706.342.8320
www.madisonmuseum.org/

Marietta

Marietta/Cobb Museum of Art
30 Atlanta Street 30060
770.528.1444
www.mariettasquare.com/mcma

Savannah

Telfair Museum of Art
121 Barnard Street 31401
912.232.1177
www.telfair.org/

Hawaii

Honolulu

Art Gallery, University of Hawaii at Manoa
2535 The Mall 96822
808.956.6888
www.hawaii.edu/artgallery/

The Contemporary Museum
2411 Makiki Heights Drive 96822
808.526.0232
www.tcmhi.org/

Honolulu Academy of Arts
900 South Beretania Street 96814-1495
808.532.8700
www.honoluluacademy.org/

Idaho

Boise

Boise Art Museum
670 Julia Davis Drive 83702
208.345.8330
www.boiseartmuseum.org/

Student Union Gallery at Boise State University
1910 University Drive 83725-1335
208.426.4636
union.boisestate.edu/gallery/

Moscow

Prichard Art Gallery
University of Idaho
414 South Main Street 83843
208.885.3586
www.uidaho.edu/galleries/bottom-
frame.html

Ridenbaugh Student Art Gallery
Ridenbaugh Hall
University of Idaho 83843
208.885.6043
www.uidaho.edu/galleries/ridenbaugh/

Illinois

Bloomington

Merwin and Wakeley Galleries
Ames School of Art
Illinois Wesleyan University
6 Ames Plaza West 61702
309.556.3391
titan.iwu.edu/~art/galler.html

Carbondale

University Museum
Southern Illinois University at Carbondale
Faner Hall North 62901
618.453.5388
www.museum.siu.edu

Carterville

John A. Logan College Museum
700 Logan College Road 62918
618.985.3741
www.jalc.edu/museum

Charleston

Tarble Arts Center
Eastern Illinois University
600 Lincoln Avenue 61920
217.581.2787
www.eiu.edu/~tarble/

Chicago

The Art Institute of Chicago
111 South Michigan Avenue 60603
312.443.3600
www.artic.edu/aic/

APPENDIX

The Field Museum
1400 South Lake Shore Drive 60605-2496
312.922.9410
www.fieldmuseum.org/

Loyola University Museum of Art
820 North Michigan Avenue 60611
312.915.7600
www.luc.edu/luma

Mexican Fine Arts Center Museum
1852 West Nineteenth Street 60608
312.738.1503
www.mfacmchicago.org/

Museum of Contemporary Art
220 East Chicago Avenue 60611
312.280.2660
www.mcachicago.org/

Northern Illinois University Art Museum
Chicago Gallery
215 West Superior Street 60610
312.642.6010
www.vpa.niu.edu/museum/

Oriental Institute Museum
1155 East Fifty-Eighth Street 60637
773.702.7520
oi.uchicago.edu/OI/

Smart Museum of Art
University of Chicago
5550 South Greenwood Avenue 60637
773.702.0200
smartmuseum.uchicago.edu/

Dekalb

Northern Illinois University Art Museum
Altgeld Galleries
Altgeld Hall 60115
815.753.1936
www.vpa.niu.edu/museum/

Elmhurst

Elmhurst Art Museum
150 Cottage Hill Avenue 60126
630.834.0202
www.elmhurstartmuseum.org/

Evanston

Mary and Leigh Block Museum of Art
Northwestern University
40 Arts Circle Drive 60208-2410

847.491.4000
www.blockmuseum.northwestern.edu/

Freeport

Freeport Arts Center
121 North Harlem Avenue 61032
815.235.9755
www.freeportartscenter.org/

Normal

University Galleries, Illinois State University
110 Center for Visual Arts 61790-5620
309.438.5487
www.cfa.ilstu.edu/galleries/

Peoria

Heuser Art Center, Bradley University
1501 West Bradley Avenue 61625
309.676.7611
art.bradley.edu

Lakeview Museum of Arts and Sciences
1125 West Lake Avenue 61614
309.686.7000
www.lakeview-museum.org/

Quincy

Gardner Museum of Architecture and Design
332 Maine Street 62301
217.224.6873
www.gardnermuseumarchitecture.org/

Rockford

Rockford Art Museum
Riverfront Museum Park
711 Main Street 61103
815.968.2787
www.rockfordartmuseum.org/

Urbana-Champaign

Krannert Art Museum
University of Illinois at Urbana-Champaign
500 East Peabody Street 61820
217.333.1860
www.kam.uiuc.edu

Spurlock Museum
University of Illinois at Urbana-Champaign
600 South Gregory Street 61801
217.333.2360
www.spurlock.uiuc.edu/

Indiana

Anderson

> Anderson Fine Arts Center
> 32 West Tenth Street 46015
> 765.649.1248 800.213.7656
> www.andersonart.org/

Bloomington

> Indiana University Art Museum
> 1133 East Seventh Street 47405-7509
> 812.855.5445
> www.indiana.edu/~iuam/

Elkhart

> Ruthmere Museum
> 302 East Beardsley Avenue 46514
> 574.264.0330 888.287.7696
> www.ruthmere.org/

Evansville

> Evansville Museum of Arts, History, and
> Science
> 411 Southeast Riverside Drive 47713
> 812.425.2406
> www.emuseum.org/

Fort Wayne

> Fort Wayne Museum of Art
> 311 East Main Street 46802
> 260.422.6467
> www.fwmoa.org/

Gary

> IUN Gallery for Contemporary Art and
> Gallery Northwest
> Indiana University Northwest
> 3400 Broadway 46408
> 888.968.7486 219.980.6891
> www.iun.edu/~gallery/

Indianapolis

> Eiteljorg Museum of American Indian and
> Western Art
> 500 West Washington Street 46204
> 317.636.9378
> www.eiteljorg.org/

> Indianapolis Museum of Art
> 4000 Michigan Road 46208-3326
> 317.920.2660
> www.ima-art.org/

> Herron Gallery
> Indiana University Purdue University
> Indianapolis
> 735 West New York Street 46202
> 317.278.9418
> www.herron.iupui.edu/new_web/galleries/
> herron_gallery.html

Kokomo

> Kokomo Art Gallery
> Indiana University Kokomo
> 2300 South Washington Street 46904
> 765.455.9523
> www.iuk.edu/%7Ekoart/

Lafayette

> Art Museum of Greater Lafayette
> 102 South Tenth Street 47905
> 765.742.1128
> www.dcwi.com/~glma/

Muncie

> Atrium Gallery
> Ball State University
> Art and Journalism Building 47306
> 765.285.5838
> www.bsu.edu/cfa/art/atrium/

> Museum of Art
> Ball State University
> Fine Arts Building
> Riverside Avenue at Warwick Road 47306
> 765.285.5242
> www.bsu.edu/artmuseum

> Minnetrista Cultural Center
> 1200 North Minnetrista Parkway 47303
> 765.282.4848
> www.minnetrista.net/

New Albany

> Carnegie Center for Art and History
> 201 East Spring Street 47150
> 812.944.7336
> www.carnegiecenter.org/

97

APPENDIX

Notre Dame

Snite Museum of Art
University of Notre Dame 46556-0638
574.631.5466
www.nd.edu/~sniteart/

Richmond

Richmond Art Museum
350 Hub Etchison Parkway 47374-0816
765.966.0256
www.richmondartmuseum.org/

South Bend

South Bend Regional Museum of Art
120 South Saint Joseph Street 46601
574.235.9102
www.sbrma.org

Terre Haute

University Art Gallery
Indiana State University 47809
812.237.3720
www.indstate.edu/artgallery/

Swope Art Museum
25 South Seventh Street 47807
812.238.1676
www.swope.org/

West Lafayette

Purdue University Galleries
Purdue Memorial Union 47907
765.496.7899
www.cla.purdue.edu/galleries/

Valparaiso

Brauer Museum of Art
Valparaiso University Center for the Arts
1709 Chapel Drive 46383
219.464.5761
www.valpo.edu/artmuseum/

Iowa

Ames

Brunnier Art Museum
Iowa State University
290 Scheman Building 50011-1110
515.294.3342
www.museums.iastate.edu/

Octagon Center for the Arts
427 Douglas Avenue 50010
515.232.5331
www.octagonarts.org/

Cedar Rapids

Cedar Rapids Museum of Art
410 Third Avenue Southeast 52401
319.366.7503
www.crma.org/

Cedar Falls

James and Meryl Hearst Center for the
Arts
304 West Seerley Boulevard 50613
319.273.8641
www.ci.cedar-falls.ia.us/human_leisure/
hearst_center/HRST_info.htm

University of Northern Iowa Gallery of Art
Kamerick Art Building
West Twenty-Seventh Street and Hudson
Road 50614
319.273.6134
www.uni.edu/artdept/gallery/

Davenport

Figge Art Museum
225 West Second Street 52801
563.326.7804
www.figgeartmuseum.org

Des Moines

Des Moines Art Center
4700 Grand Avenue 50312-2099
515.277.4405
www.desmoinesartcenter.org/

Duboque

Dubuque Museum of Art
701 Locust Street 52001
563.557.1851
www.dbqart.com/

Fort Dodge

Blanden Memorial Art Museum, Fort
Dodge
920 Third Avenue South 50501
515.573.2316

Iowa City

University of Iowa Museum of Art
150 North Riverside Drive 52242-1789
319.335.1727
www.uiowa.edu/uima/

Mason City

Charles H. MacNider Museum
303 Second Street Southeast 50401
641.421.3666
www.macniderart.org/

Muscatine

Muscatine Art Center
1314 Mulberry Avenue 52761
563.263.8282
www.muscatineartcenter.org/

Sioux City

Sioux City Art Center
225 Nebraska Street 51101
712.279.6272
www.siouxcityartcenter.org

Waterloo

Waterloo Center for the Arts
225 Commercial Street 50701
319.291.4490
www.wplwloo.lib.ia.us/arts/

Kansas

Lawrence

Spencer Museum of Art
University of Kansas
1301 Mississippi Street 66045
785.864-4710
www.ku.edu/~sma/

Lindsborg

Birger Sandzén Memorial Gallery
401 North First Street 67456
785.227.2220
www.sandzen.org/

Manhattan

Marianna Kistler Beach Museum of Art
Kansas State University
701 Beach Lane 66506

785.532.7718
www.ksu.edu/bma/

Salina

Salina Art Center
242 South Santa Fe 67401
785.827.1431
www.salinaartcenter.org/

Topeka

Mulvane Art Museum
Washburn University
Seventeenth and Jewell
785.670.1010
www.washburn.edu/reference/mulvane/

Wichita

Wichita Art Museum
1400 West Museum Boulevard 67203
316.268.4921
www.wichitaartmuseum.org/

Ulrich Museum of Art
Wichita State University
1845 Fairmount 67260-0046
316.978.3664
www.wichita.edu/ulrich

Kentucky

Bowling Green

The Kentucky Museum
Western Kentucky University
1 Big Red Way 42101-3576
270.745.2592
www.wku.edu/Library/museum/

University of Kentucky Art Museum
Rose Street and Euclid Avenue 40506
859.257.5716
www.uky.edu/ArtMuseum/

Henderson

John James Audubon Museum
Highway 41 North 42420
270.827.1893
www.hendersonky.org/audubon/

Louisville

The Speed Art Museum
2035 South Third Street 40208

APPENDIX

502.634.2700
www.speedmuseum.org/

The Kentucky Museum of Art and Craft
715 West Main Street 40202
502.589.0102
www.kentuckyarts.org/index.cfm

Morehead

The Kentucky Folk Art Center
102 West First Street 40351
606.783.2204
www.morehead-st.edu/kfac/

Murray

University Galleries
Murray State University
Price Doyle Fine Arts Center
Curris Student Center 42071-0009
270.762.3052
www.morehead-st.edu/kfac/

Owensboro

Owensboro Museum of Fine Art
901 Frederica Street 42301
270.685.3181
omfa.museum/

Paducah

Museum of the American Quilter's Society
215 Jefferson Street 42001
270.442.8856
www.quiltmuseum.org/

Louisiana

Alexandria

Alexandria Museum of Art
933 Main Street 71309-1028
318.443.3458
www.themuseum.org/

Art Gallery, Louisiana State University
Alexandria Student Center
Highway 71 South 71302
318.445.3672
artgallery.lsua.edu/

Baton Rouge

Louisiana Art and Science Museum
100 South River Road 70802

225.344.5272
www.lasm.org/

Museum of Art
Louisiana State University
Shaw Center for the Arts 70803
225.578.4003
appl003.lsu.edu/museum/moa.nsf/index

Hammond

Clark Hall Gallery
Southeastern Louisiana University 70402
504.549.2193
www2.selu.edu/Academics/Depts/VizArts/
visual/gallery.html

Jennings

Zigler Museum
411 Clara Street 70546-5235
337.824.0114

Lafayette

Paul and Lulu Hilliard University Art Museum
University of Louisiana at Lafayette
710 East St. Mary Boulevard 70503
337.482.2278
www.thehilliard.org

Lake Charles

Abercrombie Gallery
McNeese State University
Shearman Fine Arts Center 70609
337.475.5000 800.622.3352

Monroe

Bry Art Gallery
University of Louisiana at Monroe
Bry Hall 700 University Avenue 71209
318.342-1375

Masur Museum of Art
1400 South Grand Street 71202
318.329.2237

New Orleans

Contemporary Arts Center
900 Camp Street 70130
504.528.3805
www.cacno.org/index.html

Historic New Orleans Collection
533 Royal Street 70130
504.523.4662
www.hnoc.org

The Academy Gallery
New Orleans Academy of Fine Art
5256 Magazine Street 70115
504.899.8111
www.noafa.com

New Orleans Museum of Art
One Collins Diboll Circle 70124
504.488.2631
www.noma.org/

Newcomb Art Gallery
Tulane University
Woldenberg Art Center 70118
504.865.5328
www.newcomb.tulane.edu/artindex.html

The Ogden Museum of Southern Art
University of New Orleans
925 Camp Street 70130
504.539.9600
www.ogdenmuseum.org

Opelousas

Opelousas Museum of Art
106 North Union Street 70570
337.942.4991
www.cityofopelousas.com/tourism_art.htm

Ruston

Louisiana Tech Art Galleries
Visual Arts Center 71272
318.257.3909
www.art.latech.edu/gallery_calendar.html

Shreveport

Meadows Museum of Art
Centenary College of Louisiana
2911 Centenary Boulevard 71104
318.869-5169
www.centenary.edu/departme/meadows/

R. W. Norton Art Gallery
4747 Creswell Avenue 71106-1899
318.865.4201
www.rwnaf.org

Turner Art Center Gallery
Centenary College
3000 Centenary Blvd. 71104
318.865.4201
www.centenary.edu/art/turnergallery.html

Maine

See listings on page 70.

Maryland

See listings starting on page 70.

Massachusetts

See listings starting on page 71.

Michigan

Ann Arbor

University of Michigan Museum of Art
525 South State Street 48109
734.764.0395
www.umma.umich.edu/

Battle Creek

Art Center of Battle Creek
265 East Emmett Street 49017
269.962.9511
www.artcenterofbattlecreek.org/index.html

Bloomfield Hills

Cranbrook Art Museum
39221 Woodward Avenue 48303-0801
877.462.7262
www.cranbrookart.edu/museum/

Detroit

Detroit Institute of Arts
5200 Woodward Avenue 48202
313.833.7900
www.dia.org/

Dowagiac

Museum at Southwestern Michigan College
58900 Cherry Grove Road 49047
269.782.1374
www.swmich.edu/museum

APPENDIX

Flint

Flint Institute of Arts
1120 East Kearsley Street 48503
810.234.1695
www.flintarts.org/

East Lansing

Kresge Art Museum
Michigan State University 48824
517.353.9834
www.artmuseum.msu.edu/

Michigan State University Museum
West Circle Drive 48824
517.355.7474
museum.msu.edu/

Grand Rapids

Center Art Gallery
Calvin College
Spoelhof College Center
3201 Burton Street Southeast 49546
616.526.6271
www.calvin.edu/centerartgallery/

Grand Rapids Arts Museum
155 Division Avenue North 49503-3154
616.831.1000
www.gramonline.org/

Kalamazoo

Kalamazoo Institute of Arts
314 South Park Street 49007
269.349.7775
www.kiarts.org/museum

Muskegon

Muskegon Museum of Art
296 West Webster Avenue 49440
231.720.2573
www.muskegonartmuseum.org/

Traverse City

Dennos Museum Center
Northwestern Michigan College
1701 East Front Street 49686
231.995.1055
www.dennosmuseum.org/

Saginaw

Saginaw Art Museum
1126 North Michigan Avenue 48602
989.754.2491
www.saginawartmuseum.org/

Minnesota

Duluth

Tweed Museum of Art
University of Minnesota at Duluth
1201 Ordean Court 55812
218.726.8222
www.d.umn.edu/tma/

Minneapolis

Frederick R. Weisman Art Museum
University of Minneapolis
333 East River Road 55455
612.625.9494
www.weisman.umn.edu/

Minneapolis Institute of Arts
2400 Third Avenue South 55404
612.870.3131
www.artsmia.org/

Walker Art Center
725 Vineland Place 55403
(612) 375-7622
www.walkerart.org/

Saint Paul

Minnesota Museum of American Art
50 West Kellogg Boulevard 55102
651.266.1030
www.mmaa.org/

Goldstein Museum of Design
University of Minnesota
240 McNeal Hall
1985 Buford Avenue 55122
612.624.7434
goldstein.che.umn.edu/

Saint Peter

Hillstrom Museum of Art
Gustavus Adolphus College
800 West College Avenue 56082
507.933.7200
www.gustavus.edu/oncampus/finearts/hills
trom/

Winona

Minnesota Marine Art Museum
360 Vila Street 55987
507.474.6626
www.minnesotamarineartmuseum.org

Mississippi

Biloxi

The Ohr-O'Keeffe Museum of Art
136 G. E. Ohr Street 39530
228.374.5547
www.georgeohr.org

Hattiesburg

Museum of Art
University of Southern Mississippi
College of Arts and Letters
118 College Drive 39406
www.usm.edu/visualarts/museum/aboutus.php

Jackson

Mississippi Museum of Art
201 East Pascagoula Street 39201
866.843.9278
www.msmuseumart.org/

Laurel

Lauren Rogers Museum of Art
565 North Fifth Avenue 39440
601.649.6374

Ocean Springs

Walter Anderson Museum of Art
510 Washington Avenue 39564-4632
228.872.3164
www.walterandersonmuseum.org/

University

University Museum
The University of Mississippi
Fifth Street and University Avenue 38655
662.915.7073
www.olemiss.edu/depts/u_museum/

Missouri

Cape Giradeau

Southeast Missouri Regional Museum

One University Plaza MS 4275 63701
573.651.2260
www5.semo.edu/museum/

Columbia

Museum of Art and Archeology
University of Missouri-Columbia
1 Pickard Hall
Ninth Street and University Ave 65211
573.882.3591
museum.research.missouri.edu/

Kansas City

Kemper Museum of Contemporary Art
4420 Warwick Boulevard 64111
816.783.5784
www.kemperart.org/

Mildred Lane Kemper Art Museum
1 Brookings Drive 63130
314.935.5490
www.kemperartmuseum.wustl.edu

The Nelson-Atkins Museum of Art
4525 Oak Street 64111-1873
816.561-4000
www.nelson-atkins.org/

Poplar Bluff

Margaret Harwell Art Museum
421 North Main Street 63901
573.686.8002
www.mham.org/

Saint Joseph

Albrecht Kemper Museum of Art
2818 Frederick Avenue 64506
816.233.7003
www.albrecht-kemper.org/

Saint Louis

Saint Louis University Museum of Art
O'Donnell Hall
3663 Lindell Boulevard 63103
314.977.3399
sluma.slu.edu/

Laumeier Sculpture Park
12580 Rott Road 63127
314.821.1209
www.laumeier.com/

Mildred Lane Kemper Art Museum
Washington University
Steinberg Hall
One Brookings Drive 63130
314.935.4523
kemperartmuseum.wustl.edu/

Saint Louis art Museum
One Fine Arts Drive, Forest Park 63110
314.721.0072
www.stlouis.art.museum/

Springfield

Art and Design Gallery
Missouri State University
333 East Walnut Street 65804
417.866.4861
art.missouristate.edu/faci.05set.htm

Springfield Art Museum
1111 East Brookside Drive 65807
417.837.5700
www.ci.springfield.mo.us/egov/art/

Montana

North Great Falls

C.M. Russell Museum
400 Thirteenth Street 59401-1498
406.727.8787
www.cmrussell.org/

Missoula

Missoula Art Museum
335 North Pattee 59802
406.728.0447
www.artmissoula.org/

Museum of Art and Culture
University of Montana, Missoula
Performing Arts and Radio / Television
Building 59812
406.243.2019
www.umt.edu/partv/famus/

Nebraska

Lincoln

Sheldon Memorial Art Gallery
Twelfth and R Streets 68588-0300
402.474.2461
www.sheldonartgallery.org/

Omaha

Joslyn Art Museum
2200 Dodge Street 68102-1292
402.343.3400
www.joslyn.org/

Nevada

Las Vegas

Donna Beam Fine Art Gallery
University of Nevada, Las Vegas
Alta Ham Fine Arts Building
702.895.3893
finearts.unlv.edu/Facilities/Donna_Beam
_Gallery/

Reno

Nevada Museum of Art
160 West Liberty Street 89501
775.329.3333
www.nevadaart.org/

Sheppard Art Gallery
University of Nevada at Reno
Church Fine Arts Building 89557
775.784.6658
www.unr.edu/art/site/galleriesevents/she
ppard_gallery.html

New Hampshire

See listings starting on page 73.

New Jersey

See listings on page 74.

New Mexico

Albuquerque

The Albuquerque Museum
2000 Mountain Road, NW 87104
505.243.7255
www.cabq.gov/museum/

University Art Museum
University of New Mexico
Center for the Arts 87131-1416
505.277.4001
unmartmuseum.unm.edu/

Las Cruces

University Art Gallery
New Mexico State University
D.W. Williams Art Center
University Avenue 88003-0001
505.646.2545
www.nmsu.edu/~artgal/

Roswell

Roswell Museum and Art Center
100 West Eleventh Street 88201
505.624.6744
www.roswellmuseum.org/

Sante Fe

Georgia O'Keeffe Museum
217 Johnson Street 87501
505.946.1000
www.okeeffemuseum.org/

Institute of American Indian Arts
83 Avan Nu Po Road 87505
505.424.2300
www.iaiancad.org/

Museum of Fine Arts
107 West Palace Avenue 87501
505.476.5001
www.mfasantafe.org/

Museum of Indian Arts and Culture
Camino Lejo 87505
505.476.1250
www.miaclab.org/

Museum of International Folk Art
Camino Lejo 87505
505.476.1200
www.moifa.org/

Taos

Millicent Rogers Museum
1504 Millicent Rogers Road 87571
505.758.2462
www.millicentrogers.org/

New York

See listings starting on page 74.

North Carolina

Asheville

Asheville Art Museum
2 South Pack Square 28802-1717
828.253.3227
www.ashevilleart.org/

Boone

Catherine Smith Gallery
Appalachian State University
Farthing Auditorium
733 River Street 28608
828.262.6084
www.oca.appstate.edu/csg/

Brevard

Spiers Gallery
Brevard College
Sims Art Building
400 North Broad Street 28712
828.884.8188
www.brevard.edu/art/gallery%20main.html

Chapel Hill

Ackland Art Museum
University of North Carolina at Chapel Hill
Columbia Street 27599-3400
919.966.5736
www.ackland.org/visit/index.html

Charlotte

Levine Museum of the New South
200 East Seventh Street 28202
704.333.1887
www.museumofthenewsouth.org/

The Light Factory
345 North College Street 28202
704.333.9755

Mint Museum of Art
2730 Randolph Road 28207
704.337.2000
www.mintmuseum.org/

Mint Museum of Craft and Design
220 North Tryon Street 28202
704.337.2000
www.mintmuseum.org/

APPENDIX

Durham

Nasher Museum of Art
Duke University
2001 Campus Drive 27705
919.684.5135
www.nasher.duke.edu/

Fayetteville

Fayetteville Museum of Art
839 Stamper Road 28303
919.485.5121
www.fayettevillemuseumart.org/

Rosenthal Gallery
Fayetteville State University
Performing and Fine Arts Department
1200 Murchison Road 28301
910.672.1057
www.fayettevillemuseumart.org/

Greensboro

Guilford College Art Gallery
Guilford College, Hege Library
5800 West Friendly Avenue 27410
336.316.2438
www.guilford.edu/artgallery/

Weatherspoon Art Museum
University of North Carolina at Greensboro
Anne and Benjamin Cone Building
Spring Garden and Tate Streets 27402
336.334.5770
weatherspoon.uncg.edu/

Wellington B. Gray Gallery
East Carolina University
Fifth Street 27858
252.328.6336
www.ecu.edu/graygallery/

Hickory

Hickory Museum of Art
243 Third Avenue NE 28601
828.327.8576
www.hickorymuseumofart.org/

Raleigh

Artspace
201 East Davie Street 27601
919.821.2787
www.artspacenc.org/

Gallery of Art and Design
North Carolina State University
Talley Student Center
Cates Avenue 27695-7306
919.515.3503
gad.ncsu.edu/

North Carolina Museum of Art
2110 Blue Ridge Road 27607-6494
919.839.6262
ncartmuseum.org/

Salisbury

Waterworks Visual Arts Center
123 East Liberty Street 28144
704.636.1882
www.waterworks.org/pages/1/index.htm

Wilmington

Louis Wells Cameron Art Museum
3201 South Seventh Street 28412
910.395.5999
www.cameronartmuseum.com/

Winston-Salem

Charlotte and Philip Hanes Art Gallery
Wake Forest University
Scales Fine Arts Center 27106
336.758.5795
www.wfu.edu/academics/art/gallery/gall_in
dex.html

Diggs Gallery
Winston-Salem State University
C. G. O'Kelly Library 27110-0001
336.750.2458
www.wssu.edu/

Reynolda House Museum of American Art
2250 Reynolda Road 27106
336.725.5150 888.663.1149
www.reynoldahouse.org/

Southeastern Center for Contemporary Art
750 Marguerite Drive 27106
336.725.1904
www.secca.org

North Dakota

Bismarck

Gannon and Elsa Forde Galleries
Bismarck State College

1500 Edwards Avenue 58506
800.445.5073 701.224.5520
www.bismarckstate.edu/

Fargo

Memorial Union Gallery
North Dakota State University
Administration Avenue 58105
701.231.7900
www.ndsu.nodak.edu/memorial_union/gallery/

Plains Art Museum
704 First Avenue North 58102
701.232.3821
www.plainsart.org/

Grand Forks

North Dakota Museum of Art
University of North Dakota
Centennial Drive 58202
701.777.4195
www.ndmoa.com/

Minot

Taube Museum of Art
2 North Main 58702
701.838.4445
www.taubemuseum.org/

Ohio

Akron

Akron Art Museum
70 East Market Street 44308-2084
330.376.9185
www.akronartmuseum.org/

Athens

Kennedy Museum of Art
Ohio University, Lin Hall 45701
740.593.1304
www.ohiou.edu/museum/

Ohio University Art Gallery
Seigfred Hall 45701
740.593.0796
www.cats.ohiou.edu/art/galleries.html

Canton

Canton Museum of Art
1001 Market Avenue North 44702

330.453.7666
www.neo.rr.com/cma/

Cincinnati

Cincinnati Art Museum
953 Eden Park 45202
513.721.2787
www.cincinnatiartmuseum.org/

Contemporary Arts Center
44 East Sixth Street 45202
513.345.8400
www.contemporaryartscenter.org

Taft Museum of Art
316 Pike Street 45202
513.241.0343
www.taftmuseum.org/

Cleveland

Museum of Contemporary Art Cleveland
8501 Carnegie Avenue 44106
216.421.8671
www.mocacleveland.org/

Cleveland Institute of Art
Reinberger Galleries
11141 East Boulevard 44106
www.cia.edu/galleries/reinberger/

Cleveland Museum of Art
University Circle
11150 East Boulevard 44106
216.421.7350
www.clevelandart.org

Cleveland State University Art Gallery
2307 Chester Avenue 44114
216.687.2103
www.csuohio.edu/art/gallery/

Columbus

Columbus Museum of Art
480 East Broad Street 43215
(614) 221-6801
www.columbusmuseum.org/

Wexner Center for the Arts
The Ohio State University
1871 North High Street 43210-1393
614.292.3535
www.wexarts.org/ex

Dayton

 Dayton Art Institute
 456 Belmonte Park North 45405-4700
 937.223.5277
 www.daytonartinstitute.org/

 Dayton Visual Arts Center
 118 North Jefferson Street 45402
 937.224.3822
 www.sinclair.edu/dvac/home.htm

Massillon

 Massillon Museum
 121 Lincoln Way East 44646-6633
 330.833.4061
 www.massillonmuseum.org/

Oberlin

 Allen Memorial Art Museum
 Oberlin College
 87 North Main Street 44074
 440.775.8665
 www.oberlin.edu/allenart/

Oxford

 Miami University Art Museum
 801 South Patterson Avenue 45056
 513.529.2232
 www.fna.muohio.edu/amu/

Springfield

 Springfield Museum of Art
 107 Cliff Park Road 45501
 937.325.4673
 www.spfld-museum-of-art.org/

Toledo

 Toledo Museum of Art
 2445 Monroe Street 43620
 800.644.6862 419.255.8000
 www.toledomuseum.org/home.html

Wooster

 The College of Wooster Art Museum
 Ebert Art Center
 1220 Beall Avenue 44691
 330.263.2495
 artmuseum.wooster.edu/

Youngstown

 Butler Institute of American Art
 524 Wick Avenue 44502
 330.743.1711
 www.butlerart.com/butler_youngstown.htm

 McDonough Museum of Art
 Youngstown State University
 525 Wick Avenue 44555
 330.941.1400
 mcdonoughmuseum.ysu.edu/

Oklahoma

Norman

 Fred Jones, Jr., Museum of Art
 University of Oklahoma
 55 Elm Street 73019
 405.325.3272
 www.ou.edu/fjjma/

Oklahoma City

 Oklahoma City Art Museum
 415 Couch Drive 73102
 800.579.9278 405.236.3100
 www.okcartmuseum.com/

Tulsa

 Gilcrease Museum
 1400 North Gilcrease Museum Road
 74127
 918.596.2700
 www.gilcrease.org/

 Philbrook Museum of Art
 2727 South Rockford Road 74114
 800.324.7941 918.748.5309
 www.philbrook.org/

Oregon

Ashland

 Schneider Museum of Art
 Southern Oregon University
 1250 Siskiyou Boulevard 97403-1223
 541.552.6245
 www.sou.edu/sma/

Coos Bay

 Coos Art Museum
 235 Anderson Avenue 97420

541.267.3901
www.coosart.org/

Eugene

Jordan Schnitzer Museum of Art
University of Oregon
1430 Johnson Lane 97403-1223
541.346.3027
www.uoma.uoregon.edu/

Lane Community College Art Gallery
4000 East Thirtieth Avenue 97405
541.463.5409
www.lanecc.edu/artad/galleryinfo.htm

Grants Pass

Grants Pass Museum of Art
229 Southwest G Street 97526
541.479.3290
www.gpmuseum.com/

Hood River

International Museum of Carousel Art
304 Oak Street 97031
541.387.4622
www.carouselmuseum.com/

Marylhurst

The Art Gym
Marylhurst University
17600 Pacific Highway 97036-0261
800.634.9982 503.636.8141
www.marylhurst.edu/artgym/index.html

Portland

Buckley Center Gallery
University of Portland
5000 North Willamette Boulevard 97203
503.283.7258
www.up.edu/

Hoffman Gallery
Oregon College of Arts and Crafts
8245 Southwest Barnes Road 97225
800.390.0632 503.297.5544
www.ocac.edu/

Littman Gallery
Portland State University
1802 Southwest Tenth Avenue 97207
503.725.5656

Northview Gallery
Portland Community College
12000 Southwest 49th Street 97219
503.977.4269
www.pcc.edu/

Philip Feldman Gallery
Pacific Northwest College of Art
1241 NW Johnson Street 97209
503.226.4391
www.pnca.edu/

Portland Art Museum
1219 Southwest Park Avenue 97205
503.226.2811
www.pam.org/

Portland Institute for Contemporary Art
219 Northwest Twelfth Avenue 97209
503.242.1419
www.pica.org/index_fl.html

Douglas F. Cooley Memorial Art Gallery
Reed College
3202 Southeast Woodstock Blvd. 97202
503.771.1112
web.reed.edu/gallery/

Pennsylvania

See listings starting on page 77.

Rhode Island

See listings starting on page 79.

South Carolina

Charleston

Charleston Museum
360 Meeting Street 29403
843.722.2996
www.charlestonmuseum.org/

Gibbes Museum of Art
135 Meeting Street 29401
843.722.2706
www.gibbesmuseum.org/

Columbia

Columbia Museum of Art
Main and Hampton Streets 29201
803.799.2810
www.colmusart.org/

McKissick Museum
University of South Carolina
816 Bull Street 29208
803.777.7251
www.cas.sc.edu/mcks/

South Carolina State Museum
301 Gervais Street 29202
803.737.4921
www.museum.state.sc.us/

Greeneville

Bob Jones University Museum and Gallery
Bob Jones University
1700 Wade Hampton Boulevard 29614
864.242.5100
www.bjumg.org/

Greenville County Museum of Art
420 College Street 29601
864.271.7570
www.greenvillemuseum.org/

Pawleys Island

Huntington Sculpture Garden
1931 Brookgreen Drive 29576
843.235.6000
www.brookgreen.org/bridge.html

Spartanburg

Art Gallery
University of South Carolina-Spartanburg
Visual Arts Center
800 University Way 97205
864.503.5838
www.uscs.edu/

Milliken Gallery
Converse College
580 East Main Street 29302
864.596.9177
www.sparklenet.com/conversecollege/art/

Spartanburg County Arts Center
385 South Spring Street 29306
864.582.7616
www.spartanburgartmuseum.org

South Dakota

Brookings

South Dakota Art Museum
South Dakota State University

Medary Ave at Harvey Dunn 57007
605.688.5423
www3.sdstate.edu/Administration/SouthDa
kotaArtMuseum/Index.cfm

Mobridge

Klein Museum Art Gallery
1820 West Grand Crossing 57601
(605) 845-7243
www.thedahl.org/

Rapid City

Dahl Arts Center
713 Seventh Street 57701
605.394.4101
www.thedahl.org/

Vermillion

The Main Gallery
University Art Galleries
University of South Dakota
Warren M. Lee Center for the Fine Arts
605.677.5481
www.usd.edu/cfa/Art/tableofcontents.cfm

Tennessee

Chattanooga

George Ayers Cress Gallery of Art
University of Tennessee at Chattanooga
Vine and Palmetto Streets 37403
423.755.4600
www.utc.edu/cressgallery/

Hunter Museum of American Art
10 Bluff View 37403-1197
423.267.0968
www.huntermuseum.org/

Outdoor Museum of Art
Chattanooga State Technical Community
College
4501 Amnicola Highway
423.697.2606
www.chattanoogastate.edu/art_museum/a
rtmain.asp

Collegedale

Lynn H. Wood Archaeological Museum
Southern Adventist University
Hackman Hall 37315
423.236.2030

Gatlinburg

Arrowmont School of Arts and Crafts
556 Parkway 37738
865.436.5860
www.arrowmont.org/

Jefferson City

Omega Gallery
Carson-Newman College
Warren Art Building
2130 Branner Avenue 37760
865.471.2000
web.cn.edu/cncad/gallery.html

Johnson City

B. Carroll Reece Museum
East Tennessee State University
Stout Drive 37614
423.439.4392
cass.etsu.edu/museum/

Knoxville

Ewing Gallery of Art and Architecture
University of Tennessee
Art and Architecture Building
Pat Summitt Drive 37996
865.974.3199

Frank H. McClung Museum
University of Tennessee
1327 Circle Park Drive 37996-3200
865.974.2144
mcclungmuseum.utk.edu/

Knoxville Museum of Art
1050 World's Fair Park 37916-1653
865.525.6101
www.knoxart.org/

Memphis

Art Museum of the University of Memphis
142 Communication and Fine Arts Building
3750 Norriswood Avenue 38152
901.678.2224
www.people.memphis.edu/~artmuseum/

The Dixon Gallery and Gardens
4339 Park Avenue 38117
901.761.5250
www.dixon.org/

Memphis Brooks Museum of Art
1934 Poplar Avenue 38104
901.544.6200
www.brooksmuseum.org/

Nashville

Cheekwood Botanical Garden and
Museum of Art
1200 Forrest Park Drive 37207
615.356.8000
www.cheekwood.org/index.html

Fine Arts Gallery, Vanderbilt University
23rd Street and West End Avenue 37203
615.322.0605
sitemason.vanderbilt.edu/gallery

Fisk University Galleries
1000 17th Avenue North 37208
615.329.8720
www.fisk.edu/index.asp

Frist Center for the Visual Arts
919 Broadway 37203-3822
615.244.3340
www.fristcenter.org/site/default.aspx

Tennessee State Museum
Polk Cultural Center
505 Deaderick Street 37243
615.741.2692 800.407.4324
www.tnmuseum.org/

Sewanee

University Art Gallery
University of the South
Guerry Hall
Georgia Avenue 37383
931.598.1000

Texas

Albany

Old Jail Art Center
201 South Second 76430
325.762.2269
www.theoldjailartcenter.org/

Amarillo

Amarillo Museum of Art
2200 South Van Buren 79109
806.371.5050
www.amarilloart.org/

111

APPENDIX

Austin

 Austin Museum of Art
 AMOA-Downtown
 823 Congress Avenue 78701
 512.495.9224
 www.amoa.org/

 Austin Museum of Art
 AMOA-Laguna Gloria
 3809 West Thirty-Fifth Street 78703
 512.458.8191
 www.amoa.org/

 Jack S. Blanton Museum of Art
 University of Texas at Austin, Art Building
 Congress Avenue and Martin Luther King
 Junior Boulevard 78712
 512.471.7324
 www.blantonmuseum.org/

 Harry Ransom Humanities Research Center
 University of Texas at Austin
 Twenty-First and Guadalupe 78713
 512.471.8944
 www.hrc.utexas.edu/

Beaumont

 Art Museum of Southeast Texas
 500 Main Street 77701
 409.832.3432
 www.amset.org/

College Station

 J. Wayne Stark University Center Galleries
 Texas A & M University
 Memorial Student Center 77843
 979.845.8501
 stark.tamu.edu/

Dallas

 Dallas Museum of Art
 1717 North Harwood 75201
 214.922.1200
 www.dm-art.org/

 Meadows Museum
 Southern Methodist University
 5900 Bishop Boulevard 75275-0357
 214.768.2516
 www.meadowsmuseumdallas.org/

 Nasher Sculpture Center
 2001 Flora Street 75201

 214.242.5100
 www.nashersculpturecenter.org/

El Paso

 El Paso Museum of Art
 One Arts Festival Plaza 79901
 915.532.1701
 www.elpasoartmuseum.org/

Fort Worth

 Amon Carter Museum
 3501 Camp Bowie Boulevard 76107-2695
 817.738.1933
 www.cartermuseum.org/

 Kimbell Art Museum
 3333 Camp Bowie Boulevard 76107-2792
 817.332.8451
 www.kimbellart.org/

 Modern Art Museum
 3200 Darnell Street 76107
 866.824.5566 817.738.9215
 www.themodern.org/

Houston

 Blaffer Gallery
 University of Houston
 120 Fine Arts Building 77204-4018
 713.743.9530
 www.hfac.uh.edu/blaffer/

 Contemporary Arts Museum
 5216 Montrose Boulevard 77006-6598
 713.284.8250
 www.camh.org/

 Houston Center for Contemporary Craft
 4848 Main Street 77002
 713.529.4848
 www.crafthouston.org/

 Museum of Fine Arts
 1001 Bissonnet Street 77005
 713.639.7300
 www.mfah.org/

 Menil Collection
 1515 Sul Ross 77006
 713.525.9400
 www.menil.org/

 Rice Gallery, Rice University
 6100 Main Street 77005

713.348.6069
www.ricegallery.org/

Longview

Longview Museum of Fine Arts
215 East Tyler Street 75601
903.753.8103
www.lmfa.org/

Lubbock

Landmark Arts Galleries
Texas Tech University School of Art
Eighteenth and Flint Streets 79409-2081
806.742.1947
www.art.ttu.edu/artdept/lndmrk.html/

Odessa

Ellen Noël Art Museum of the Permian Basin
4909 East University Boulevard 79762
432.550.9696
www.noelartmuseum.org/

San Antonio

ArtPace
445 North Main Avenue 78205-1441
210.212.4900
www.artpace.org/

Marion Koogler McNay Art Museum
6000 North New Braunfels 78209
210.824.5368
www.mcnayart.org/

Museum of Art
200 West Jones Avenue 78215
210.978.8100
www.samuseum.org

Utah

Cedar City

Braithwaite Fine Arts Gallery
Southern Utah University
351 West Center Street 84720
435.586.5432
www.suu.edu/pva/artgallery/

Logan

Nora Eccles Harrison Museum of Art
Utah State University
650 North 1100 East Logan 84322-4020

435.797.0163
www.usu.edu/artmuseum

Provo

Museum of Art
Brigham Young University
North Campus Drive 84602
801.422.8287
cfac.byu.edu/moa/

Salt Lake City

Utah Museum of Fine Art
410 Campus Center Drive 84112-0350
801.581.7332
www.umfa.utah.edu/

Springville

Springville Museum of Art
126 East 400 South 84663
801.489.2727
www.sma.nebo.edu/

Vermont

See listings on page 80.

Virginia

See listings starting on page 80.

Washington

Goldendale

Maryhill Museum of Art
35 Maryhill Museum Drive 98620
509.773.3733
www.maryhillmuseum.org/

Pullman

Museum of Art
Washington State University
Wilson Road and Stadium Way 99164
509.335.1910
www.wsu.edu/artmuse/

Seattle

Frye Art Museum
704 Terry Avenue 98104
206.622.9250
www.fryeart.org/
Henry Art Gallery

113

University of Washington
Fifteenth Avenue Northeast and
Northeast Forty-First Street 98195
(206) 543-2280
www.henryart.org/

Burke Museum of Natural History and
Culture
University of Washington
Seventeenth Avenue Northeast and
Northeast Forty-Fifth Street 98195
206.543.5590
www.washington.edu/burkemuseum/

Seattle Art Museum
100 University Street 98101-2902
206.654.3100
www.seattleartmuseum.org/

Spokane

Jundt Art Museum
Gonzaga University
202 East Cataldo Avenue 99201
509.323.3891
www.gonzaga.edu/

Tacoma

Tacoma Art Museum
1123 Pacific Avenue 98402-4399
253.272.4258
www.tacomaartmuseum.org/

Bellingham

Whatcom Museum of History and Art
121 Prospect Street 98225
360.676.6981
www.whatcommuseum.org/

West Virginia

See listings on page 83.

Wisconsin

Beloit

Wright Museum of Art, Beloit College
College Street and Bushnell Street 53511
205.254.2566
www.beloit.edu/~museum/wright/

Madison

Chazen Museum of Art
University of Wisconsin Madison
800 University Avenue 53706
608.263.2246
chazen.wisc.edu/

Madison Museum of Contemporary Art
Overture Center for the Arts
227 State Street 53703
608.257.0158
www.mmoca.org

James Watrous Gallery of the Wisconsin
Center of Sciences, Arts and Letters
Overture Center for the Arts
201 State Street 53703
608.265.2500
www.wisconsinacademy.org/gallery/index.html

Wisconsin Union Galleries
University of Wisconsin-Madison
Memorial Union
800 Langdon Street 53706
608.265.3000
www.sit.wisc.edu/~wudart/

Manitowoc

Rahr-West Art Museum
610 North Eighth Street 54220
920.683.4501
www.rahrwestartmuseum.org/

Milwaukee

Charles Allis Art Museum
1801 North Prospect Avenue 53202
414.278.8295
www.cavtmuseums.org/

Haggerty Museum of Art
Marquette University
Thirteenth and Clybourn Streets 53201
414.288.1669
www.marquette.edu/haggerty/

Milwaukee Art Museum
700 North Art Museum Drive 53202
414.224.3200
www.mam.org

Milwaukee Institute of Art & Design
273 East Erie Street 53202
414.276.7889
www.miad.edu/

Villa Terrace
Decorative Arts Museum
2220 North Terrace Avenue 53202
414.271.3656
www.cavtmuseums.org/

Neenah

Bergstrom-Mahler Museum
165 North Park Avenue 54956
920.751.4658
www.bergstrom-mahlermuseum.com/

Oshkosh

Allen Priebe Gallery
University of Wisconsin-Oshkosh
Arts and Communications Building
926 Woodland Avenue 54901
205.254.2566
www.uwosh.edu/art/galleries/

Paine Art Center and Gardens
1410 Algoma Boulevard 54901
920.235.6903
www.thepaine.org/

Racine

Charles A. Wustum Museum of Fine Arts
2519 Northwestern Avenue 53404
262.636.9177
www.ramart.org/08_wustum_museum/inde
x.php

Racine Art Museum
441 Main Street 53401
262.638.8300
www.ramart.org/

Sheboygan

John Michael Kohler Arts Center
608 New York Avenue 53082-0489
920.458.6144
www.jmkac.org/

Wausau

Leigh Yawkey Woodson Art Museum
700 North Twelfth Street 54403-5007
715.845.7010
www.lywam.org/

West Bend

West Bend Art Museum
300 South Sixth Avenue 53095
262.334.9638
www.wbartmuseum.com

Whitewater

Crossman Gallery
University of Wisconsin-Whitewater
Greenhill Center of the Arts
950 West Main Street 53190
262.472.5708
academics.uww.edu/CAC/art/uww-
art%20dept/web2/site/crossman.html

Wyoming

Cheyenne

Wyoming State Museum
Barrett Building
2301 Central Avenue 82002
307.777.7022
wyomuseum.state.wy.us/

Jackson Hole

National Museum of Wildlife Art
2820 Rungius Road 83001
800.313.9553 307.733.5771
www.wildlifeart.org/

Laramie

University of Wyoming Art Museum
2111 Willett Drive 82071-3807
307.766.6622
www.uwyo.edu/artmuseum/

Sundance

Crook County Museum and Art Gallery
309 Cleveland Street 82729-0063
307.283.3666
www.wyshs.org/mus-crookcty.htm

APPENDIX

A Selection of Museums Around the World

The Art Gallery of New South Wales
Sydney, Australia
www.artgallery.nsw.gov.au/
This site offers access to the collections of the Sydney's Art Gallery of New South Wales Museum, including Australian, Aboriginal, Asian, western and contemporary art, and photography.

The Art Gallery of Ontario
Ontario, Canada
www.ago.net/navigation/flash/index.cfm
This site offers access to the collections of the the Art Gallery of Ontario, including paintings, sculpture, prints and drawings including European 15th-20th century and British 18th-20th century.

The Ashmolean Museum
Oxford, England
www.ashmol.ox.ac.uk/
This site provides access to the collections of the University of Oxford's Ashmolean Museum. Among the departments are antiquities, the cast gallery, the coin room, Eastern art, and Western art.

The Benaki Museum
Athens, Greece
www.benaki.gr/index-en.htm
Access to the art collections and the photographic and historical archives of the Benaki Museum are featured at this site.

The British Museum
London, England
www.thebritishmuseum.ac.uk/
Among this site's highlights is the opportunity to explore the British Museum's collections, which are organized under these categories: Africa, Americas, Asia, Britain, Egypt, Europe, Greece, Japan, Near East, Pacific, and Rome.

The Egyptian Museum
Cairo, Egypt
www.egyptianmuseum.gov.eg/
This site provides access to the wide variety of objects ranging from the prehistoric era to the Greco-Roman period.

Galleria degli Uffizi
Florence, Italy
www.uffizi.firenze.it/
This site provides access to the collections of the Florence's Uffizi Gallery, with information about its history and its buildings.

Guggenheim Museum
Bilbao, Spain
www.guggenheim-bilbao.es/ingles/home.htm
This site provides access to the collections of the Guggenheim Museum in Bilbao, Spain, with information about its collection, exhibitions, and buildings.

Hong Kong Museum of Art
www.lcsd.gov.hk/CE/Museum/Arts/index.html
This site provides access to the collections, exhibitions, and activities associated with the Hong Kong Museum of Art.

Hunterian
Glasgow, Scotland
www.hunterian.gla.ac.uk/
This site provides access to the collections of the museum and art gallery at the University of Glasgow.

Kunsthistorisches Museum
Vienna, Austria
www.mbam.qc.ca/a-sommaire.html
This site provides access to the collections of Vienna's Kunsthistorisches Museum, with information about its collection, exhibitions, and buildings.

Montreal Museum of Fine Arts
Montreal, Canada
www.mbam.qc.ca/
This site provides access to the collections of the Montreal Museum of Fine Arts, featuring Canadian art, Inuit art, and art by European masters.

Musée du Louvre
Paris, France
www.louvre.fr/
Enjoy a virtual tour of the Louvre Museum in Paris by visiting the museum's 350 rooms with over 1,500 pictures. The site also provides a Paris Virtual Guide, featuring thousands of pictures of the City of Lights.

Musée d'Orsay
Paris, France
www.musee-orsay.fr/
Access to the Musée d'Orsay's collections is available, as well as information about the museum's building.

Museo Nacional del Prado
Madrid, Spain
museoprado.mcu.es/home.html
Access to the Prado Museum's collections is available, as well as information about the museum's building as well as current and previous exhibits.

The Museum of Classical Archaeology
Cambridge, England
www.classics.cam.ac.uk/museum/default.html
The University of Cambridge's Museum of Classical Archaeology is one of the few surviving collections of casts of Greek and Roman sculpture in the world. The public collection of the Museum is made up of over six hundred plaster casts of Greek and Roman sculptures.

The National Gallery
London, England
www.nationalgallery.org.uk/
Access to the entire collection of London's National Gallery of Art is available at this site. Extensive categories assist the search.

National Gallery of Australia
Canberra, Australia
www.nga.gov.au/Home/index.cfm
This site provides access to the collections of the National Gallery of Australia collections of Australian and international art plus information about its exhibitions.

National Gallery of Canada
Ottawa, Canada
musee.beaux-arts.ca/
This site provides access to the collections of the National Gallery of Canada in Ottawa. Among the departments are Canadian art and Inuit art.

The National Gallery of Ireland
Dublin, Ireland
www.nationalgallery.ie/
The National Gallery of Ireland's collection of Irish art and European master paintings is available through this site.

National Galleries of Scotland
Edinburgh, Scotland
www.nationalgalleries.org/
This site provides access to the collections of Scotland's National Gallery, National Portrait Gallery, and National Gallery of Modern Art.

The National Gallery of Wales
Cardiff, Wales
www.nmgw.ac.uk/art/
Information about the collections of the art museum, and its collection of British and European art.

The National Museum of Modern Art
Tokyo, Japan
www.momat.go.jp/english_page/
Information about the collections of the art museum, the crafts gallery, and the film center is available at this site.

National Palace Museum
Taipei, Taiwan
www.npm.gov.tw/main/fmain_en.htm
This site provides access to one of the most extensive collections of Chinese Art at Taiwan's National Palace Museum, featuring ceramics, porcelain, calligraphy, painting, and ritual bronzes.

National Portrait Gallery
London, England
www.npg.org.uk/live/index.asp
Founded in 1856, the National Portrait Gallery in London is the most comprehensive of its kind in the world. The site offers a convenient tool for searching the online database of gallery images.

Rijksmuseum
Amsterdam, Netherlands
rijksmuseum.nl/asp/start.asp?language=uk
Access to the extensive holdings of the Rijksmuseum is available through this site. A highlight is the virtual tour of 150 museum rooms and 1,250 of the museum's most popular exhibits.

Royal Academy
London, England
www.royalacademy.org.uk/
This site provides access to the Royal Academy's collections plus information about its exhibitions.

Royal Museums of Fine Arts of Belgium
Brussels, Belgium
www.fine-arts-museum.be/site/EN/default.asp
This site provides access to the museums, collections, and exhibitions of the Museum of Ancient Art, the Museum of Modern Art, the Wiertz Museum, and the Meunier Museum.

APPENDIX

Royal Ontario Museum
Toronto, Canada
www.rom.on.ca/
This site provides access to the galleries, collections, and exhibitions of the Royal Ontario Museum.

Shanghai Art Museum
Shanghai, China
www.cnarts.net/shanghaiart/
Among the Shanghai Art Museum's collections are calligraphy, photography, sculpture, ceramics, and watercolors.

The State Hermitage Museum
St. Petersburg, Russia
www.hermitagemuseum.org/html_En/index.html
Situated in the center of St. Petersburg, the State Hermitage Museum is housed in five magnificent buildings created by celebrated architects of the 18th to 19th Centuries. Assembled throughout two and a half centuries, the Hermitage's collections of works of art (over 3,000,000 items) present the development of the world culture and art from the Stone Age to the 20th Century.

Staatliche Museen
Berlin, Germany
www.smb.spk-berlin.de/e/m.html
This site provides information about sixteen national museums located in Berlin.

Tate Collections
London, England
www.tate.org.uk/
This site provides access to the entire collection of Britain's Tate Museums—over 25,000 works of British and international art, each with its own information page.

The Vatican Museums
Rome, Italy
www.vatican.va/phome_en.htm
Through this site, access is available to the Vatican library, museum, and archives. Information about the Vatican as a city-state is also provided. Gaining virtual access to the Vatican's extensive art collection is sufficient reason to visit this site.

The Victoria and Albert Museum
London, England
www.vam.ac.uk/
This site features information about London's Victoria and Albert Museum, with access to it collections, its exhibitions, and its history.

The Whitworth Art Gallery
Manchester, England
www.whitworth.man.ac.uk/
This site features information about the collections, exhibitions, and events at the Whitworth Art Gallery.

Glossary

Abacus — The slab that forms the upper part of a capital.

Academy — Derived from Akademeia, the name of the garden where Plato taught his students; the term came to be applied to official (generally conservative) teaching establishments.

acrylic — A clear plastic used to make paints and as a casting material in sculpture.

aesthetic — Describes the pleasure derived from a work of art, as opposed to any practical or informative value it might have. In philosophy, aesthetics is the study of the nature of art and its relation to human experience.

agora — In ancient Greek cities, the open marketplace, often used for public meetings.

aisle — In church architecture, the long open spaces parallel to the nave.

allegory — A dramatic or artistic device in which the superficial sense is accompanied by a deeper or more profound meaning.

altar — In ancient religion, a table at which offerings were made or victims sacrificed. In Christian churches, a raised structure at which the sacrament of the Eucharist is consecrated, forming the center of the ritual.

Altarpiece — A painted or sculptured panel placed above and behind an altar to inspire religious devotion.

ambulatory — Covered walkway around the apse of a church.

amphora — Greek wine jar.

anthropomorphism — The endowing of nonhuman objects or forces with human characteristics.

apse — Eastern end of a church, generally semicircular, in which the altar is housed.

architecture — The art and science of designing and constructing buildings for human use.

architrave — The lowest division of an entablature.

archivault — The molding that frames an arch.

assemblage — The making of a sculpture or other three-dimensional art piece from a variety of materials. Compare collage, montage.

atelier — A workshop.

atrium — An open court in a Roman house or in front of a church.

autocracy — Political rule by one person of unlimited power.

avant-garde — French for advance-guard. Term used to describe artists using innovative or experimental techniques.

axis — An imaginary line around which the elements of a painting, sculpture or building are organized, established by the direction and focus of these elements.

Bronze Age — The period during which bronze (an alloy of copper and tin) was the chief material for tools and weapons. It began in Europe around 3000 B.C.E. and ended around 1000 B.C.E. with the introduction of iron.

barrel vault — A semicircular vault unbroken by ribs or groins.

bas-relief — Low relief; see relief.

basilica — Originally a large hall used in Roman times for public meetings, law courts, etc.; later applied to a specific type of early Christian church.

black figure — A technique used in Greek vase painting which involved painting figures in black paint in silhouette and incising details with a sharp point. It was used throughout the Archaic period. Compare red figure.

burin — Steel tool used to make copper engravings.

buttress — An exterior architectural support.

Corinthian — An order of architecture that was popular in Rome, marked by elaborately decorated capitals bearing acanthus leaves. Compare Doric, Ionic.

caliph — An Arabic term for leader or ruler.

calligraphy — The art of penmanship and lettering.

campanile — In Italy the bell tower of a church, often standing next to but separate from the church building.

canon — From the Greek meaning a "rule" or "standard." In architecture it is a standard of proportion. In religious terms it represents the authentic books in the

Bible or the authoritative prayer of the Eucharist in the Mass or the authoritative law of the church promulgated by ecclesiastical authority.

capital — The head, or crowning part, of a column, taking the weight of the entablature.

capitulary — A collection of rules or regulations sent out by a legislative body.

cartoon — (1) A full-scale preparatory drawing for a picture, generally a large one such as a wall painting. (2) A humorous drawing.

caryatid — A sculptured female figure taking the place of a column.

cast — A molded replica made by a process whereby plaster, wax, clay, or metal is poured in liquid form into a mold. When the material has hardened the mold is removed, leaving a replica of the original from which the mold was taken.

catharsis — Literally, "purgation." Technical term used by Aristotle to describe the emotional effect of a tragic drama upon the spectator.

cathedra — The bishop's throne. From that word comes the word cathedral, i.e., a church where a bishop officiates.

cella — Inner shrine of a Greek or Roman temple.

ceramics — Objects made of baked clay, such as vases and other forms of pottery, tiles, and small sculptures.

chancel — The part of a church east of the nave that includes choir and sanctuary.

chapel — A small space within a church or a secular building such as a palace or castle, containing an altar consecrated for ritual use.

chevet — The eastern (altar) end of a church.

chiaroscuro — In painting, the use of strong contrasts between light and dark.

choir — The part of a church chancel between nave and sanctuary where the monks sing the Office; a group of singers.

classical — Generally applied to the civilizations of Greece and Rome; more specifically to Greek art and culture in the 5th and 4th centuries B.C.E. Later imitations of classical styles are called neoclassical. Classical is also often used as a broad definition of excellence: a "classic" can date to any period.

clerestory — A row of windows in a wall above an adjoining roof.

cloister — The enclosed garden of a monastery, surrounded by a covered walkway; by extension the monastery itself. Also, a covered walkway alone.

codex — A manuscript volume.

coffer — In architecture, a recessed panel in a ceiling.

collage — A composition produced by pasting together disparate objects such as train tickets, newspaper clippings, or textiles. Compare assemblage, montage.

colonnade — A row of columns.

composition — Generally, the arrangement or organization of the elements that make up a work of art.

concetto — Italian for "concept." In Renaissance and Baroque art, the idea that undergirds an artistic ensemble.

consul — One of two Roman officials elected annually to serve as the highest state magistrates in the Republic.

contrapposto — In sculpture, placing a human figure so that one part (e.g., the shoulder) is turned in a direction opposite to another part (e.g., the hip and leg).

cornice — The upper part of an entablature.

cruciform — Arranged or shaped like a cross.

crypt — A vaulted chamber, completely or partially underground, which usually contains a chapel. It is found in a church under the choir.

cult — A system of religious belief and its followers.

cuneiform — A system of writing, common in the ancient Near East, using characters made up of wedge shapes. Compare hieroglyphics.

Doric — One of the Greek orders of architecture, simple and austere in style. Compare Corinthian, Ionic.

daguerreotype — Early system of photography in which the image is produced on a silver-coated plate.

design — The overall conception or scheme of a work of art. In the visual arts, the organization of a work's composition based on the arrangement of lines or contrast between light and dark.

dialectics — A logical process of arriving at the truth by putting in juxtaposition contrary propositions; a term often used in medieval philosophy and theology, and also in the writings of Hegel and Marx.

dome — A hemispherical vault.

Epicurean — A follower of the Greek philosopher Epicurus, who held that pleasure was the chief aim in life.

echinus — The lower part of the capital.

elevation — In architecture, a drawing of the side of a building that does not show perspective.

encaustic — A painting technique using molten wax colored by pigments.

engraving — (1) The art of producing a depressed design on a wood or metal block by cutting it in with a tool. (2) The impression or image made from such a wood or metal block by ink that fills the design. Compare burin, etching, woodcut.

entablature — The part of a Greek or Roman temple above the columns, normally consisting of architrave, frieze, and cornice.

entasis — The characteristic swelling of a Greek column at a point about a third above its base.

epithet — Adjective used to describe the special characteristics of a person or object.

etching — (1) The art of producing a depressed design on a metal plate by cutting lines through a wax coating and then applying corrosive acid that removes the metal under the lines. (2) The impression or image made from such a plate by ink that fills the design. Compare engraving, woodcut.

evangelist — One of the authors of the four Gospels in the Bible: Matthew, Mark, Luke, and John.

facade — The front of a building.

ferroconcrete — A modern building material consisting of concrete and steel reinforcing rods or mesh.

flute — Architectural term for the vertical grooves on Greek (and later) columns.

foreshortening — The artistic technique whereby a sense of depth and three-dimensionality is obtained by the use of receding lines.

form — The arrangement of the general structure of a work of art.

fresco — A painting technique that employs the use of pigments on wet plaster.

frieze — The middle section of an entablature. A band of painted or carved decoration, often found running around the outside of a Greek or Roman temple.

Gesamtkunstwerk — German for "complete work of art." The term, coined by Wagner, refers to an artistic ensemble in which elements from literature, music, art, and the dance are combined into a single artistic totality.

Greek cross — A cross with arms of equal length.

gallery — A long, narrow room or corridor, such as the spaces above the aisles of a church.

genre — A type or category of art. In the visual arts, the depiction of scenes from everyday life.

glaze — In oil painting a transparent layer of paint laid over a dried painted canvas. In ceramics a thin coating of clay fused to the piece by firing in a kiln.

gospels — The four biblical accounts of the life of Jesus, ascribed to Matthew, Mark, Luke, and John. Compare evangelist.

gouache — An opaque watercolor medium.

graphic — Description and demonstration by visual means.

ground — A coating applied to a surface to prepare it for painting.

guilloche — A decorative band made up of interlocking lines of design.

hadith — Islamic law/traditions outside of the Qu'ran.

haj — The Islamic pilgrimage to Mecca.

hamartia — Literally Greek for "missing the mark," "failure," or "error." Term used by Aristotle to describe the character flaw that would cause the tragic end of an otherwise noble hero.

happening — In art, a multimedia event performed with audience participation so as to create a single artistic expression.

hedonism — The philosophical theory that material pleasure is the principal good in life.

hegira — Muhammad's flight from Mecca to Medina; marks the beginning of the Islamic religion.

hierarchy — A system of ordering people or things which places them in higher and lower ranks.

hieroglyphics — A system of writing in which the characters consist of realistic or stylized pictures of actual objects, animals, or human beings (whole or part). The Egyptian hieroglyphic script is the best known, but by no means the only one. Compare cuneiform.

hippodrome — A race course for horses and chariots. Compare spina.

hubris — The Greek word for "insolence" or "excessive pride."

humanist — In the Renaissance, someone trained in the humane letters of the ancient classics and employed to use those skills. More generally, one who studies the humanities as opposed to the sciences.

Ionic — One of the Greek orders of architecture, elaborate and grace-ful in style. Compare Doric, Corinthian.

Iron Age — The period beginning in Europe around 1000 B.C.E. during which iron was the chief material used for tools and weapons.

icon — Greek word for "image." Panel paintings used in the Orthodox church as representations of divine realities.

iconography — The set of symbols and allusions that gives meaning to a complex work of art.

ideal — The depiction of people, objects, and scenes according to an idealized, preconceived model.

idol — An image of a deity that serves as the object of worship.

image — The representation of a human or nonhuman subject, or of an event.

impasto — Paint laid on in thick textures.

incising — Cutting into a surface with a sharp instrument.

intercolumniation — The horizontal distance between the central points of adjacent columns in a Greek or Roman temple.

jamb — Upright piece of a window or a door frame, often decorated in medieval churches.

keystone — Central stone of an arch.

kore — Type of standing female statue produced in Greece in the Archaic period.

kouros — Type of standing male statue, generally nude, produced in Greece in the Archaic period.

Latin cross — A cross with the vertical arm longer than the horizontal arm.

lancet — A pointed window frame of a medieval Gothic cathedral.

landscape — In the visual arts, the depiction of scenery in nature.

lekythos — Small Greek vase for oil or perfume, often used during funeral ceremonies.

line engraving — A type of engraving in which the image is made by scored lines of varying width.

lintel — The piece that spans two upright posts.

lithography — A method of producing a print from a slab of stone on which an image has been drawn with a grease crayon or waxy liquid.

liturgy — The rites used in public and official religious worship.

loggia — A gallery open on one or more sides, often with arches.

lunette — Semicircular space in wall for window or decoration.

lyre — Small stringed instrument used in Greek and Roman music. Compare cithara.

lyric — (1) Words or verses written to be set to music. (2) Description of a work of art that is poetic, personal, even ecstatic in spirit.

Madonna — Italian for "My Lady." Used for the Virgin Mary.

Mass — The most sacred rite of the Catholic liturgy.

mandorla — Almond-shaped light area surrounding a sacred personage in a work of art.

matroneum — Gallery for women in churches, especially churches in the Byzantine tradition.

mausoleum — Burial chapel or shrine.

meander — Decorative pattern in the form of a maze, commonly found in Greek Geometric art.

metopes — Square slabs often decorated with sculpture which alternated with triglyphs to form the frieze of a Doric temple.

michrab — A recessed space or wall design in a mosque to indicate direction of Mecca for Islamic worshippers.

mobile — A sculpture so constructed that its parts move either by mechanical or natural means.

monastery — A place where monks live in communal style for spiritual purposes.

monochrome — A single color, or variations on a single color.

montage — (1) In the cinema, the art of conveying an idea and/or mood by the rapid juxtaposition of different images and camera angles. (2) In art, the kind of work made from pictures or parts of pictures already produced and now forming a new composition. Compare assemblage, collage.

mosaic — Floor or wall decoration consisting of small pieces of stone, ceramic, shell, or glass set into plaster or cement.

mosque — Islamic house of worship.

mullions — The lines dividing windows into separate units.

mural — Wall painting or mosaics attached to a wall.

myth — Story or legend whose origin is unknown; myths often help to explain a cultural tradition or cast light on a historical event.

Neanderthal — Early stage in the development of the human species, lasting from before 100,000 B.C.E. to around 35,000 B.C.E.

Neolithic — Last part of the Stone Age, when agricultural skills had been developed but stone was still the principal material for tools and weapons. It began in the Near East around 8000 B.C.E. and in Europe around 6000 B.C.E.

narthex — The porch or vestibule of a church.

nave — From the Latin meaning "ship." The central space of a church.

niche — A hollow recess or indentation in a wall to hold a statue or other object.

obelisk — A rectangular shaft of stone that tapers to a pyramidal point.

oculus — A circular eye-like window or opening.

oil painting — Painting in a medium made up of powdered colors bound together with oil, generally linseed.

order — (1) In classical architecture a specific form of column and entablature; see Doric, Ionic, and Corinthian. (2) More generally, the arrangement imposed on the various elements in a work of art.

orientalizing — Term used to describe Greek art of the 7th century B.C.E. that was influenced by Eastern artistic styles.

Paleolithic — The Old Stone Age, during which human beings appeared and manufactured tools for the first time. It began around two and a half million years ago.

palette — (1) The tray on which a painter mixes colors. (2) The range and combination of colors typical of a particular painter.

panel — A rigid, flat support, generally square or rectangular, for a painting; the most common material is wood.

pantheon — The collected gods. By extension, a temple to them. In modern usage a public building containing the tombs or memorials of famous people.

pantocrator — From the Greek meaning "one who rules or dominates all." Used for those figures of God and/or Christ found in the apses of Byzantine churches.

parable — A story told to point up a philosophical or religious truth.

pastel — A drawing made by rubbing colored chalks on paper.

pathos — That aspect of a work of art that evokes sympathy or pity.

pediment — The triangular space formed by the roof cornices on a Greek or Roman temple.

pendentives — Triangular architectural devices used to support a dome of a structure; the dome may rest directly on the pendentives. Compare squinches.

peripatetic — Greek for "walking around." Specifically applied to followers of the philosopher Aristotle.

peristyle — An arcade (usually of columns) around the outside of a building. The term is often used of temple architecture.

perspective — A technique in the visual arts for producing on a flat or shallow surface the effect of three dimensions and deep space.

piazza — Italian term for a large, open public square.

pieta — An image of the Virgin with the dead Christ.

pietra serena — Italian for "serene stone." A characteristic building stone often used in Italy.

pilaster — In architecture a pillar in relief.

plan — An architectural drawing showing in two dimensions the arrangement of space in a building.

podium — A base, platform, or pedestal for a building, statue, or monument.

polis — The Greek word for "city," used to designate the independent city-states of ancient Greece.

polychrome — Several colors. Compare monochrome.

portal — A door, usually of a church or cathedral.

portico — A porch with a roof supported by columns.

pre-socratic — Collective term for all Greek philosophers before the time of Socrates.

prophet — From the Greek meaning "one who speaks for another." In the Hebrew and Christian tradition it is one who speaks with the authority of God. In a secondary meaning, it is one who speaks about the future with authority.

proportion — The relation of one part to another, and each part to the whole, in respect of size, whether of height, width, length, or depth.

prototype — An original model or form on which later works are based.

psalter — Another name for the Book of Psalms from the Bible.

Qur'an — The sacred scriptures of Islam.

realism — A 19th-century style in the visual arts in which people, objects, and events were depicted in a manner that aimed to be true to life. In film, the style of Neorealism developed in the post-World War II period according to similar principles.

red figure — A technique used in Greek vase painting that involved painting red figures on a black background and adding details with a brush. Compare black figure.

relief — Sculptural technique where- by figures are carved out of a block of stone, part of which is left to form a background. Depending on the degree to which the figures project, the relief is described as either high or low.

reliquary — A small casket or shrine in which sacred relics are kept.

requiem — A Mass for the dead.

revelation — Divine self-disclosure to humans.

sanctuary — In religion, a sacred place. The part of a church where the altar is placed.

sarcophagus — From the Greek meaning "flesh eater." A stone (usually limestone) coffin.

satire — An amusing exposure of folly and vice, which aims to produce moral reform.

satyr — Greek mythological figure usually shown with an animal's ears and tail.

scale — More generally, the relative or proportional size of an object or image.

scriptorium — That room in a medieval monastery in which manuscripts were copied and illuminated.

section — An architectural drawing showing the side of a building.

secular — Not sacred; relating to the worldly.

silhouette — The definition of a form by its outline.

spandrel — A triangular space above a window in a barrel vault ceiling, or the space between two arches in an arcade.

spina — A monument at the center of a stadium or hippodrome, usually in the form of a triangular obelisk.

squinches — Either columns or lintels used in corners of a room to carry the weight of a superimposed mass. Their use resembles that of pendentives.

stele — Upright stone slab decorated with relief carvings, frequently used as a grave marker.

still life — A painting of objects such as fruit, flowers, dishes, etc., arranged to form a pleasing composition.

stoa — A roofed colonnade, generally found in ancient Greek open markets, to provide space for shops and shelter.

stoic — School of Greek philosophy, later popular at Rome, which taught that the universe is governed by Reason and that Virtue is the only good in life.

stretcher — A wooden or metal frame on which a painter's canvas is stretched.

stylobate — The upper step on which the columns of a Greek temple stand.

summa — The summation of a body of learning, particularly in the fields of philosophy and theology.

sura — A chapter division in the Qur'an, the scripture of Islam.

syllogism — A form of argumentation in which a conclusion is drawn from a major premise by the use of a minor premise: all men are mortal/Socrates is a man/ therefore Socrates is mortal.

symmetry — An arrangement in which various elements are so arranged as to parallel one another on either side of an axis.

tabernacle — A container for a sacred object; a receptacle on the altar of a Catholic church to contain the Eucharist.

tambour — The drum that supports the cupola of a church.

tempera — A painting technique using coloring mixed with egg yolk, glue, or casein.

terra cotta — Italian meaning "baked earth." Baked clay used for ceramics. Also sometimes refers to the reddish-brown color of baked clay.

tesserae — The small pieces of colored stone used for the creation of a mosaic.

tholos — Term in Greek architecture for a round building.

toga — Flowing woolen garment worn by Roman citizens.

tragedy — A serious drama in which the principal character is often brought to disaster by his/her hamartia, or tragic flaw.

transept — In a cruciform church, the entire part set at right angles to the nave.

triglyphs — Rectangular slabs divided by two vertical grooves into three vertical bands; these alternated with metopes to form the frieze of a Doric temple.

triptych — A painting consisting of three panels. A painting with two panels is called a diptych; one with several panels is a polyptych.

trompe l'oeil — From the French meaning "to fool the eye." A painting technique by which the viewer seems to see real subjects or objects instead of their artistic representation.

trumeau — A supporting pillar for a church portal, common in medieval churches.

tympanum — The space, usually decorated, above a portal, between a lintel and an arch.

value — The property of a color that makes it seem light or dark.

vanishing point — In perspective, the point at which receding lines seem to converge and vanish.

vault — A roof composed of arches of masonry or cement construction.

volutes — Spirals that form an Ionic capital.

votive — An offering made to a deity either in support of a request or in gratitude for the fulfillment of an earlier prayer.

voussoirs — Wedge-shaped blocks in an arch.

woodcut — (1) A wood block with a raised design produced by gouging out unwanted areas. (2) The impression or image made from such a block by inking the raised surfaces. Compare engraving, etching, lithograph.

ziggurat — An Assyrian or Babylonian stepped pyramid.